WEYMOUTH & PORTLAND AT WORK

FIONA TAYLOR

GW00570240

AMBERLEY

First published 2018

Amberley Publishing
The Hill, Stroud
Gloucestershire, GL5 4EP

www.amberley-books.com

Copyright © Fiona Taylor, 2018

The right of Fiona Taylor to be identified as the Author
of this work has been asserted in accordance with the
Copyrights, Designs and Patents Act 1988.

ISBN 978 1 4456 8485 7 (print)
ISBN 978 1 4456 8486 4 (ebook)

British Library Cataloguing in Publication Data.
A catalogue record for this book is available
from the British Library.

Origination by Amberley Publishing.
Printed in the UK.

CONTENTS

Introduction	4
Section One	5
Weymouth: A Brief History	5
Sea bathing	7
The Arrival of the Railway	11
Cosens	22
Brewing	32
Wyke Regis and Whitehead	37
Section Two	48
Portland – A Brief History	48
Fishing and Farming	50
Portland Stone	58
The Breakwater and the Royal Navy	79
HM Prison Portland	89
The Future for Weymouth and Portland	94
Bibliography	95
Acknowledgements	96

INTRODUCTION

The Jurassic Coast stretches from Exmouth in East Devon to Old Harry Rocks, near Swanage in Dorset. Its 96 miles long and is a World Heritage Site. Weymouth and Portland are situated along this stretch of coast in South Devon. Both are distinct towns with their own unique histories and characters, but both have been influenced by their coastal geography: Weymouth with its long golden sands, making it a quintessential British seaside resort, and Portland with its limestone, known worldwide for its building qualities.

Industries and trades evolved from this coastal setting, some of which I attempt to explore in this book. Today many of these jobs are no longer in existence, but if one looks closely there are traces of past working lives hidden today in the landscape, giving us tantalising glimpses into our ancestors' pasts.

In this book I look at both towns separately and describe their past industries and how they have influenced the development of each of these areas. Unfortunately, I only have the space for the larger industries, but I acknowledge that many of the smaller industries support and can be just as important a role in building the soul of a community.

The Dorset flag flying proudly in the sky.

SECTION ONE

WEYMOUTH: A BRIEF HISTORY

Weymouth is situated on a sheltered bay at the mouth of the River Wey. There is evidence that Romans sailed up the Wey as far as Radipole, where they would transport cargo to the Roman town of Durnovaria (Dorchester).

In the Middle Ages Weymouth consisted of two separate towns: Weymouth on the south side of the river and harbour, and Melcombe Regis on the north side. Each had its own government and MP. Both these settlements, despite their close proximity to the sea, were orientated to the river and the harbour, as shipping and trade were the mainstay of the economy. These two towns sharing one harbour sometimes led to heated and violent disputes.

In July 1348, the Black Death was introduced to England through the port of Melcombe Regis by a Gascon sailor. Many of the townsfolk fled to escape infection, thus spreading the disease further inland.

Radipole Lake – once a tidal estuary fed by the River Wey. Today it is a nature reserve.

By the sixteenth century there was such bitter rivalry between Weymouth and Melcombe Regis that Elizabeth I granted a royal charter to unite the two communities into a single borough in 1571. The first bridge across the harbour was built in 1597. Until then, one reached the other side by a small ferry boat – an experience that can still be enjoyed today.

During the Civil War, in 1645, both sides of the river suffered considerable damage. Parliamentarians were in charge of the town, but a group of Royalists very nearly succeeded in taking over. Attacking Royalists from Weymouth and nearby Portland bombarded their Parliamentarian enemies in Melcombe Regis during the siege of Weymouth, which lasted nineteen days. Approximately 900 Parliamentarians held out against 4,500 Royalist.

Daniel Defoe, who visited in 1720s, stated, 'Weymouth is a sweet, clean agreeable town, considering its low situation and closeness to the sea, 'tis well-built and has a great many substantial merchants in it; who drive a considerable trade and have a good number of ships belonging to the town.' This was the last account of the town before sea bathing started to make waves and put Weymouth on the map.

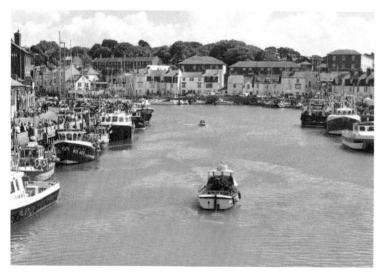

Weymouth Harbour, taken from the Town Bridge.

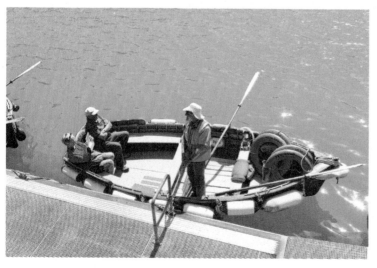

The ferry that operates today runs between the Nothe Parade and old Melcombe Regis. It's a traditional clinker boat and the job is kept for retired seafarers and fishermen.

A cannonball lodged in the gables of a house possibly fired by Royalist ships during the Civil War.

SEA BATHING

From the late seventeenth century there was a radical new fad with sea bathing. It was believed that dipping in salty, cold water could cure all manners of ills. By the 1730s a number of coastal towns were playing host to wealthy visitors wishing to bathe. The first reference to bathing in Weymouth is 1748, when permission was sought by R. Prowse and Jos Bennett to build two bathing machines.

In 1750, Ralph Allen, the entrepreneur and philanthropist, bought a house on the south side of Weymouth Harbour, attracted by the medicinal benefits of cold-sea bathing. He recommended the curative effects of the waters to the Duke of York, who visited in 1758, and his brother, the Duke of Gloucester, who spent the winter of 1780 in the town.

This was the beginning of the resort, referred to by the *Sherborne Mercury* as lacking the 'genteel accommodation' such a place required but the paper predicted, 'There was the greatest probability that Weymouth would be the most frequented place in the Kingdom.' So, by the 1780s Weymouth was already a thriving resort, but in 1789 a visit took place that was to rank Weymouth at the top of the most fashionable place to be seen amongst the Georgian socialites: George III came to recuperate following a bout of porphyria, which affected his mental health. The king came to visit with his wife and four eldest daughters and they stayed at Gloucester Lodge.

A week after his arrival George III dipped his toes into the sea for the first time. On the beach there was a bathing machine waiting for him with two royal female dippers who would help him take the plunge. The king ascended the steps into the machine and a horse was then hitched to the seaward end of it. The horse slowly began to trundle the machine and King George (who was disrobing inside) towards the waves.

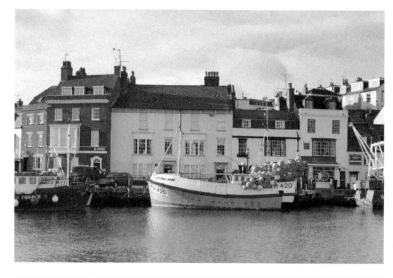

Ralph Allen's House, with a fishing boat moored in front. He is credited as being a great promoter of Bath.

Gloucester Lodge, built in 1780 for the Duke of Gloucester. It was later used by George III as his holiday residence.

Once in deep water, the horse went back to shore, seaward-facing doors were opened, steps were let down and the monarch descended for the first time into the blue sheltered waters of Weymouth Bay. Two female dippers where waiting for him. They grabbed him by the shoulders and when a good strong wave came along they plunged him underneath. A band concealed in a neighboring machine, struck up 'God Save Our King', much to the surprise of George III and his entourage.

The visit was a big success. The queen declared that the king was 'much better and stronger for the sea bathing'. Life in Weymouth suited the king and he came back in 1791, and then almost every year until 1805, and he made Gloucester Lodge his official summer residence.

Royal patronage guaranteed the popularity of the resort among the privileged and led to the rapid growth of the town. The entrepreneurial spirit of the town flourished – the focus of the town's development were now on the bay rather than the harbour. Tradesmen thrived and the demand for accommodation and entertainment led to the construction of many public buildings and houses.

One of Weymouth's most ambitious men was the young architect James Hamilton, who advised on the overall plan and design and is credited with the wonderful Regency Terrace.

On 4 October 1805, George III left Weymouth for the last time. But the king was not forgotten. Two lasting monuments to Weymouth's royal visitor remain.

The first is the White Horse: a carving of George III on horseback in the hillside at Osmington, overlooking Weymouth Bay. Created around 1808, the king was said to be dismayed that it was in the direction going away from Weymouth. As a result, the king himself never returned to the town.

The second is the King's Statue: a statue of George III in his coronation robes on Weymouth seafront. Unveiled in 1810, it has been painted in heraldic colours since 1949 and remains a popular landmark today with a replica of George's bathing machine in the gardens below it.

A replica bathing machine that is on display on the Esplanade. By 1800 there were thirty bathing machines on Weymouth Beach.

Once built as grand houses, many of these buildings along the Esplanade are now hotels.

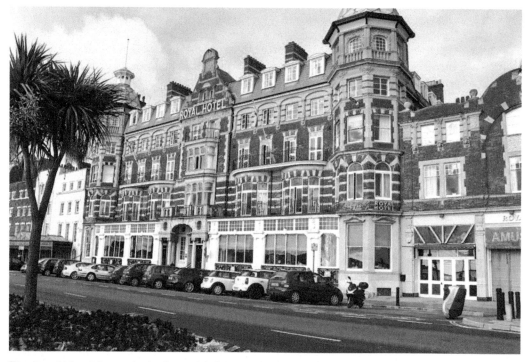

The Royal Hotel, formerly the Assembly Rooms. George III often visited. A red cord separated the royal family from the riff-raff.

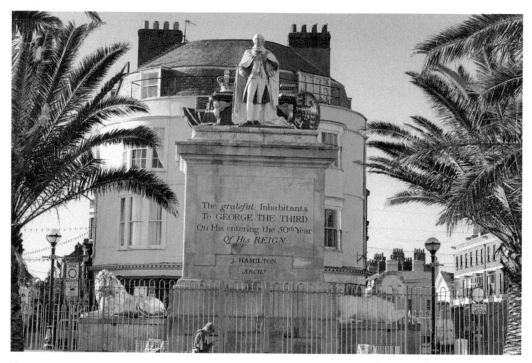

George III stands majestically above Weymouth while life carries on around him.

THE ARRIVAL OF THE RAILWAY

Sixty-eight years after George III first made his trip to Weymouth, the railway arrived on 20 January 1857. It was met with great excitement. *The Dorset County Chronicle* states that on 27 January 1857 a 'general holiday was observed by all classes'. Flags were hung from buildings and a procession, led by the mayor, marched from the town hall, accompanied by the band of the 15th Hussars, who were stationed at Dorchester. The Great Western Railway issued 300 free tickets for an excursion to Yeovil, which departed at 11.30 a.m. and arrived in Yeovil an hour later 'having been greeted at the various stations along the line by many celebrations in the shape of colours displayed, the firing of cannon, and the shouts of joy'. Later in the day a dinner was held at the Royal Hotel, which was followed by a ball at the Victoria Hotel.

The period following the opening of the railway in 1857 saw not only the expansion of the town, but also the birth of a new kind of holiday trade – mass tourism.

The town began to attract great numbers of ordinary working people, who, through cheap rail travel, could now afford to visit the seaside. The passing of the Bank Holiday Act 1871 gave the Great Western Railway the opportunity to lay on many extra trains to bring thousands of day trippers to Weymouth. Introduction of statutory holidays and a cut in fares in 1873 increased the number of visitors still further.

Visitors from Bath, Bristol and London flocked to the resort, as did employees from the GWR works in Swindon. 'Swindon Week' quickly became a part of the local calendar in early July. At its peak over 6,000 would attend. With the new visitors came new prosperity. The holiday trade brought new business opportunities. Families were able to boost their income by providing inexpensive bed and breakfast lodgings.

This train station opened on 3 July 1986 as the old Weymouth station was far too big for the traffic it was handling.

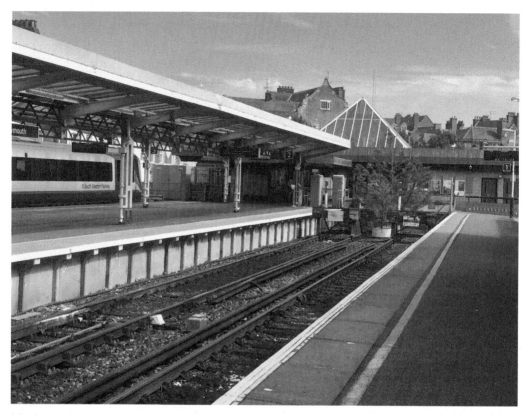

It's the end of the line. Weymouth is the southern terminus for both South Western Line from Waterloo and the heart of Wessex line from Bristol.

New forms of entertainment and catering developed. Street musicians, Punch and Judy shows, minstrel shows, acrobats, whelk stands, ice-cream carts, travelling photographers and peddlers all swarmed the beaches and promenades turning them into fairgrounds.

Weymouth has the longest-running association with Punch and Judy in the UK. It goes back to at least 1881, only breaking during the two world wars. The first reference of their presence in Weymouth dates from 1877. By 1881 Punch and Judy is was a permanent fixture. The first known puppeteer or Punch and Judy professor was a man named James Murray from Bristol, who worked from the late nineteenth century to 1912. Frank Edmonds took over the job in 1926 and clocked up fifty years entertaining the crowds. He holds the record for being the longest-running Punch and Judy professor to date. His successor Guy Higgins did another long stretch: 1976–2005. Mark Poulton has been the custodian of the show since 2005.

Weymouth has a long tradition of sand sculpturing, going back to Victorian times. Swift Vincent was one of the first sand men on Weymouth Beach, retiring in 1930. Jack Hayward (1930s–60s) specialised in cathedrals and architectural reproductions. Fred Darrington was entirely self-taught and he worked from the 1920s right up until 1996, when he retired at the age of eighty-six. Mark Anderson is the present sand sculptor; he is Fred's grandson.

The season for the wealthy visitors were considerably longer and these families were still catered for. They could use the 'House and Apartment register', which offered better-class accommodation on the Esplanade and other fashionable parts of town.

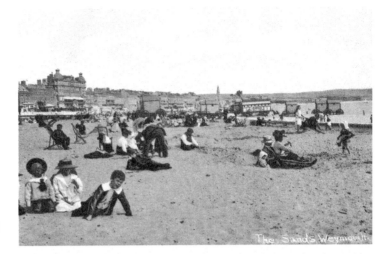

Weymouth Beach around 1904. Note the bathing machines in the background.

This is one of Nark Anderson's creative sand sculptures.

The donkeys having a welcome break before the next rides start. Donkeys have been a part of Weymouth's beach life for over a hundred years. For practically the whole of the twentieth century successive members of the Downton family ran the rides, until John Downton retired in 2000.

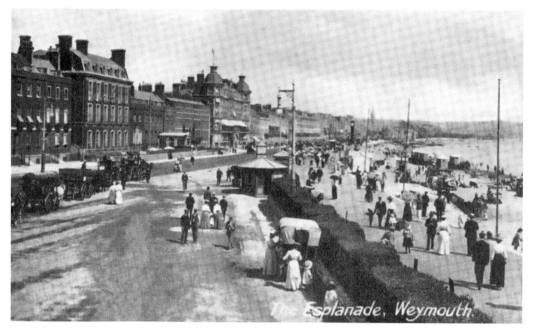

The Esplanade around 1918. Weymouth Esplanade was – and still is – one of the finest marine walks in Europe.

There was a great interest in the Register Generals annual report on the mortality figures, with resorts vying with each other to maintain the lowest death rate in much the same way as they compete with the high sunshine today.

A number of new buildings and amenities attested to the prosperity and growth of Weymouth. In the town, a general market house and a fish market were erected in the 1850s.

In 1867, 'The Rings' was donated to the town for the development of public gardens; in 1880 they were renamed the Alexandra Gardens. In the 1870s, the Greenhill Gardens provided green space at the other end of the Esplanade.

Although the income from the visitors was a growing importance, the harbour still lay at the heart of Weymouth economy. The harbour saw a development of trade in this period, especially with its links to the Channel Islands.

Weymouth offered the shortest sea route to the Channel Islands and was chosen by the post office for the introduction of its packet service to Jersey and Guernsey in February 1794. Initially two post office packets, both cutters of around 80 tons, ran weekly from Weymouth.

The Weymouth Quay tramway was first opened with Great Western and South Western trains to support the Channel Island Steam Packet Service. As the port of Weymouth grew, a new system was required to maintain the level of freight passing through the town. With the growth of the national rail network the tramway was built and opened in 1865, with the first trains being pulled by horses. The railway line was extended to the ferry terminal to form the Quay Tramway, with services connecting passenger ferries as well as goods shipped by cargo vessels using the port. Regular cargoes of clay coal and agricultural exports went through the port with potatoes, tomatoes and broccoli being sought after. Potatoes were so popular that there were special Jersey potato boats and trains running twice a week, with an average of 12,000 tons a season being imported.

The fish market dates from 1855 and still sells local catches today.

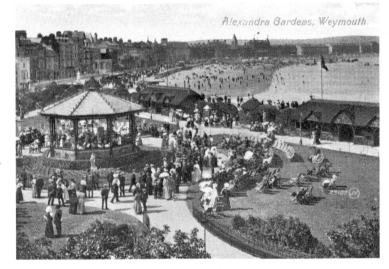

Alexandra Gardens. Unfortunately the concert hall you can see in the photograph was destroyed by fire in 1993.

Alexandra Gardens today.

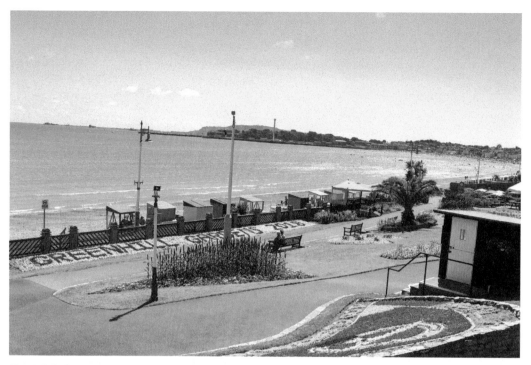

Greenhill Gardens has been recognised as one of the best green spaces in the country by being awarded Green Flag status.

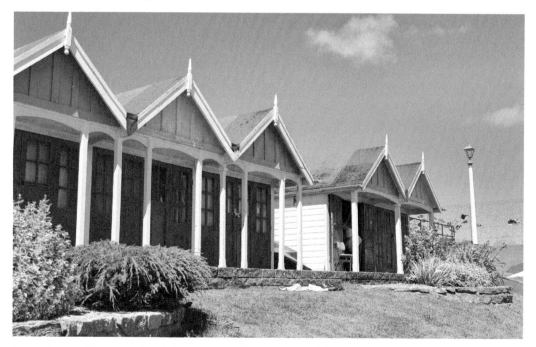

Beach huts at Greenhill. Beach huts are the descendents of the bathing baths – they give you privacy but take up less space.

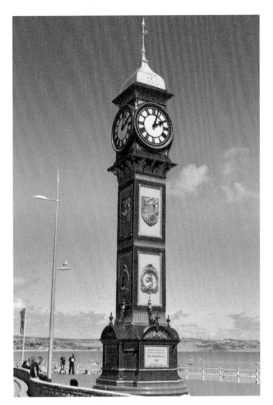

Right: The Jubillee Clock was erected in 1887 in honour of Queen Victoria's fifty years on the throne.

Below: The Esplanade was adorned by a series of cast-iron shelters, erected in 1889.

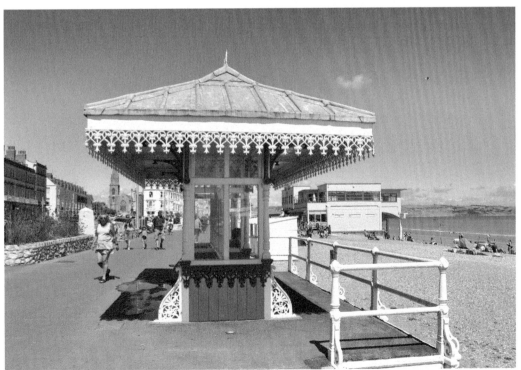

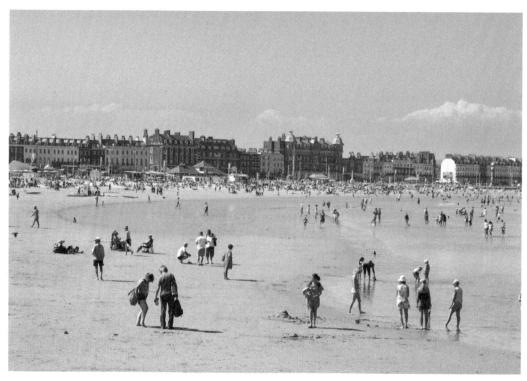

Weymouth remains a popular resort.

The humble deckchair remains a feature of the British seaside.

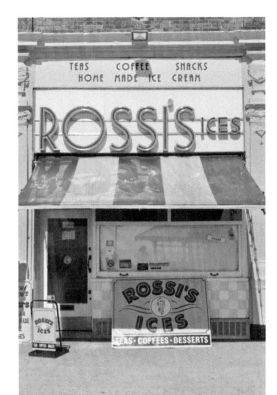

Right: Rossi's was established in the 1930s by Italian immigrant Fioravanti Figliolini – a firm favourite in Weymouth for home-made ice cream.

Below: Weymouth Harbour.

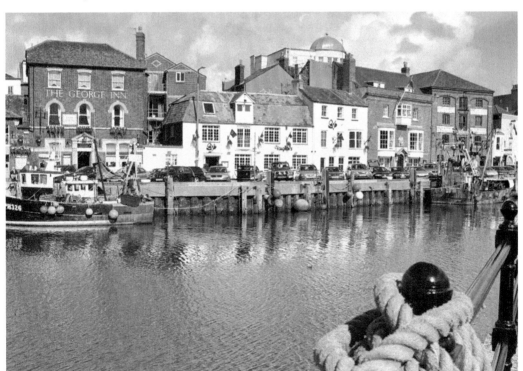

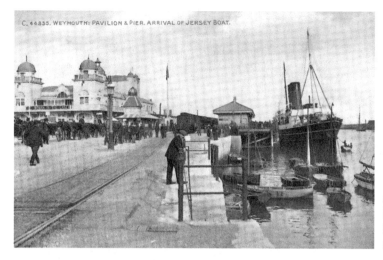

C. 44855. WEYMOUTH: PAVILION & PIER. ARRIVAL OF JERSEY BOAT.

Arrival of the Jersey Boat – note the Pavillion Theatre in the background.

The tramway was worked by the Great Western Railway (GWR) but owned by the Weymouth & Portland Railway. As loads increased in weight and frequency the first wheeled locomotive negotiated the route in 1878. In June 1880 a small locomotive was installed. The trains only travelled at 4mph, but a bell rang continuously with a policeman walking in front waving a flag to ensure people moved out of the way. By 1889 a regular passenger service also ran along the line, transporting people directly to Weymouth's ferry port where they could board a ferry service to the Channel Islands.

Great Western Railway began to operate its own ships and passenger service in 1889, causing rivalry between railway companies as the Southern Railway operated the port at Southampton. This pattern of goods and passenger services continued, with various improvements being made to the line well into the 1920s. Following the rebuilding of the Town Bridge in 1930 much of the harbourside was filled in, creating space for the development of the tramway.

In 1960 the Channel Island service ceased from Southampton, leaving Weymouth as the main UK port to serve the Channel Islands. But gradually this trade moved to other ports. Road haulage became more popular and the need for the tramway declined.

Regular freight and goods services ceased in 1972; however, fuel was still transported on the line until 1983. The last passenger train ran in 1987 when the main line to Dorset became electrified, although a summer boat service continued for some time. The last train to travel along the tramway was on 30 May 1999.

The trains may have stopped running but the tramway is still visible to visitors along the length of the old route. These tracks are controversial, however, with some calling for them to be removed as the tramway lines along Custom House Quay have been blamed for causing multiple accidents involving bicycles and motorbikes.

Weymouth's last boat connection to the Channel Islands ended in March 2015. Condor Ferries had operated from Weymouth for many years, but in 2012 they moved temporarily to Poole while repairs were being made to the Weymouth ferry berth. The repairs cost Weymouth and Portland Borough Council £4.5 million. A year after their return, Condor Ferries stated that they had purchased a larger ship and that a further £10 million would be needed to be spent on the berth to accommodate the larger ship. Pleas for government funding went unheard and in March 2015 the final ferry sailed away. It has been estimated that the harbour loses £750,000 a year because of this move.

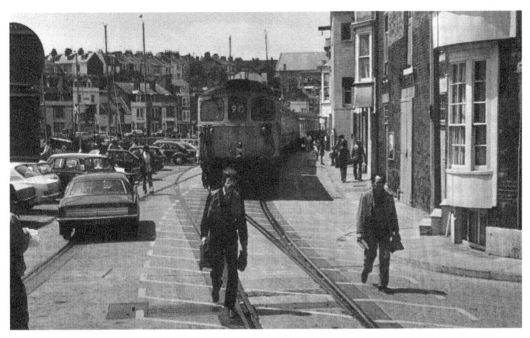

Above: The Boat Train in the 1970s.

Right: The tramway lines still visible sneaking their way along the harbourside.

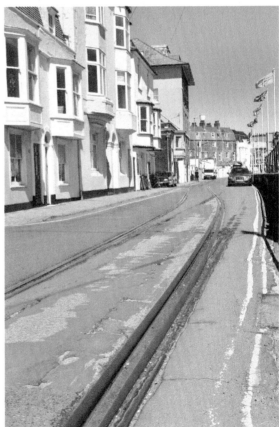

Tramway running close to Cosens Quay.

COSENS

Between 1848 and 1967 the name of Cosens was synonymous with the fleet of paddle steamer excursions that became a much-loved part of the summer scene along the south-west coast, Cherbourg and the Channel Islands. It is inextricably linked to the development of Weymouth.

Captain Joseph Cosens was an experienced sailor, having been engaged in the coastal trade and chartered his first vessel, the tug *Highland Maid*, in 1848 to capitalise on the need for a good link to the new naval dockyard at Portland. It was a successful venture. But by 1851 the business had strong competition from the Weymouth & Portland Steam Packet Company, owned by local entrepreneur Philip Dodson, who intended placing his own steamer – *Contractor* – on the same route.

Cosens thus decided to expand and went into partnership with wealthy local newspaper proprietor, Joseph Drew. A new ship was acquired named *Prince* and excursions further afield along the Dorset coast were offered, which catered for the increase in visitors due to the arrival of the railway in 1857.

Weymouth advertised itself as 'The Bay of Naples of England', with a host of attractions. Sea excursions became a summer ritual for many. They allowed the chance for escapism from the hard grind of daily life. The smoke and grime of the cities was replaced by fresh sea air. The steamers were ornate and grand with mahogany furniture and open decks. There was a dining saloon too, which served tasty meals. There was also the engine room, where one could watch the engine cranks turning.

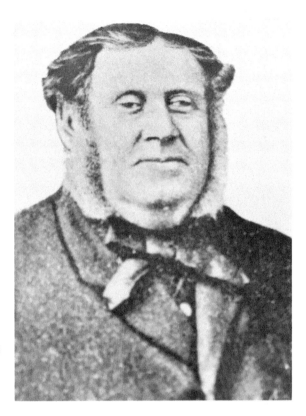

Joseph Cosens was born in Weymouth on 30 May 1816. Cosens is a very old Dorset name, which can be traced back to at least the sixteenth century.

On 10 July 1860, Philip Dodson was discovered dead in his bed. There was shock among the local community when the inquest reported suicide. But there was little sentiment from Cosens, who placed a notice in the local press that he had taken over Burden Coal Stores and other premises on Custom House Quay that had formerly been occupied by Dodson.

During the Christmas festivities of 1873 news reached Weymouth that Joseph Cosens had died suddenly while on a visit to London. Local shopkeepers immediately put up their shutters and flags were flown half-mast by shipping in the harbour as a mark for respect for a man who, through his commercial activities, contributed greatly to the economic success of Weymouth. In reporting his death, the *Dorset County Chronicle* commented:

> During the season thousands of visitors came here solely for the purpose of enjoying the excursions which were daily carried out to some of the charming spots in the locality by means of these steamboats. Apart from these, however, the deceased was a man who deeply had the interests of the town at heart ... and his advice and counsel were listened to with attention and respect. He was one of those persons whom the town could ill afford to lose, and we are sure that his death will be lamented by a large number of inhabitants.

Cosens & Co. became a Ltd company on 10 June 1876. During the late 1870s the paddle steamers Prince and Premier introduced the 'Coasting Trips' on which passengers were landed over the bows of the steamer directly on to the small beaches of Lulworth, Seaton and Sidmouth. In 1880 a pier opened at Bournemouth and from then onwards a Cosens steamer was based there every peacetime summer until 1966.

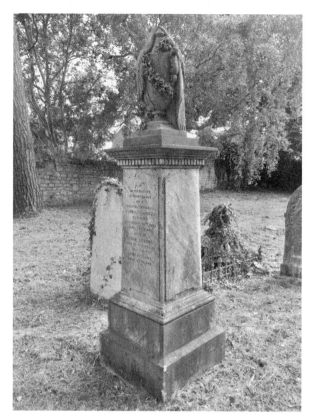

Left: Joseph Cosens' grave in Melcombe Regis Cemetery. He had expressed a wish to be laid beside his mother in the dissenter's side of the cemetery.

Below: Paddle steamer arriving at Church Ope.

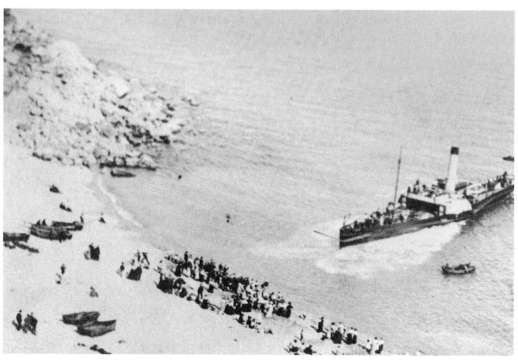

The company also generated a significant income from other activities. A lucrative contract was signed to ferry sailors to and from the warships that used Portland Harbour. They also had several salvage tugs, which towed distressed sailing vessels back to port. Extensive engineering works and a ship-repair facility grew around the harbour. Cosens also built their own refrigeration plant and imported importing Norwegian block ice as well as distribution of meat to local butchers. They were the first to bring electricity to Weymouth. With all these activities it is easy to see how it became Weymouth's biggest employer. Their 1923 guidebook boasted, 'the youth of Weymouth will remember Cosens as a stepping stone into the engineering world.'

In the years before the First World War, the company was locked in competition with rival steamer operators such as Bournemouth, Swanage, Poole Steam Packet Company and P&A Campbell Ltd. This led to a rapid expansion of both the fleet and routes. By 1914 Cosens had a fleet of eleven paddle steamers and numerous smaller vessels, with excursions as far afield as the Channel Islands, Cherbourg, Torquay and Brighton. The fleet comprised of impressively named paddle steamers such as *The Majestic, Monarch, Brodick Castle, Victoria, Empress, Queen* and *Albert Victor*.

During the First World War the fleet was requisitioned into service. Their shallow draught made them ideal for coastal minesweeping duties. The *Majestic* foundered on passage to Malta while being used for patrol service in 1916. After the war the surviving steamers returned to their peacetime roles. Despite the effects of the Great Depression and the General Strike the fleet continued its trade. Some of the older vessels, such as the *Premier*, which at ninety-two years was the oldest passenger vessel on the British register when scrapped, were replaced with newer vessels such as *Consul* and *Embassy*.

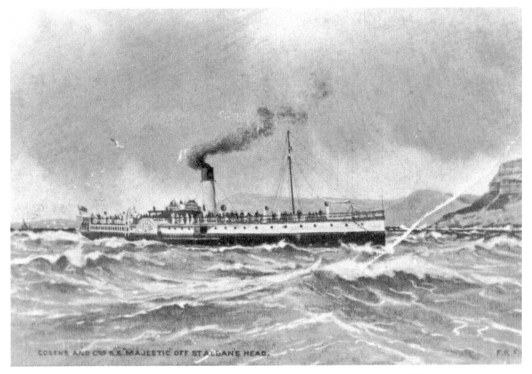

A painting by F. R. Fitzgerald of paddle steamer *Majestic* off St Albans, 1906.

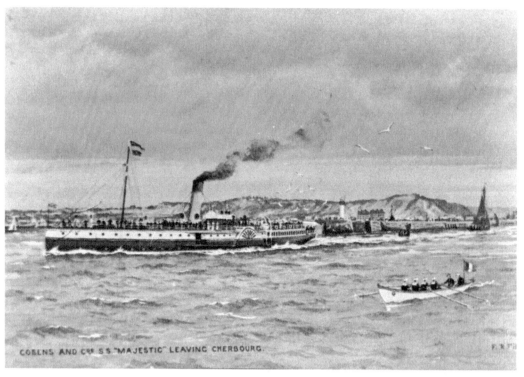

A painting by F. R. Fitzgerald of paddle steamer *Majestic* leaving Cherbourg, 1906.

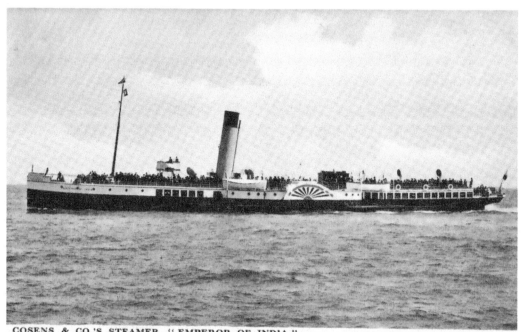

COSENS & CO.'S STEAMER, "EMPEROR OF INDIA."

Emperor of India.

The Second World War saw the fleet see active service again as minesweepers, anti-aircraft and examination vessels. The *Emperor of India* played its part at the Dunkirk evacuations, bringing home 642 soldiers.

Luckily no Cosen paddle steamers were lost during the Second World War, but trading conditions were never quite the same again. The growth of car ownership and a change of holiday habits drew passengers away from the paddle steamers.

Facing stiff competition from Southampton-based company Red Funnel, Cosens became a subsidiary in 1946. The two companies then operated under separate flags, although not in direct competition. Increased fuel and maintenance costs took their toll and by the 1950s only three steamers plied their trade. *Monarch* was withdrawn in 1961, *Consul* in 1962 and finally on 22 September 1966 *Embassy* made the last Cosens sailing from Totland Bay to Bournemouth.

But Cosens continued as Cosens Engineering Ltd with their shipyard and engineering business. They moved from their HQ at Custom House Quay to the inner harbor, and in 1987 moved to Portland. The company was sold in a management buyout in 1990.

From No. 10 Custom House Quay the Cosens management would have had an excellent view of the harbour and been able to keep an eye on their assets. In 2006 their former site at the inner harbour was renamed Cosens Quay to commemorate their long associations with Weymouth.

No. 10 Custom House Quay is the former location of Cosens Head Office, sail loft and original coal store.

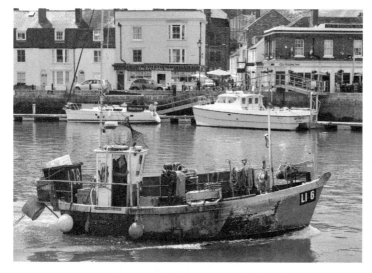

A fishing boat returns with its day's catch.

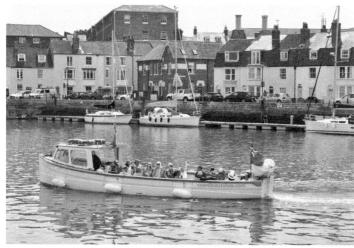

My Girl, built in 1931 and used to carry troops in the Second World War, now used for tourist excursions.

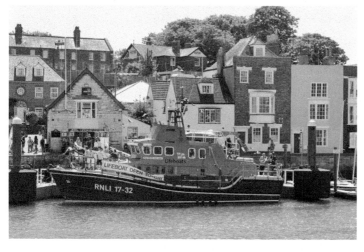

The lifeboat station was opened on 26 January 1869. The town's first lifeboat, the *Agnes Harriet*, was named at a ceremony held on the sands in front of a large crowd. This latest boat is called *Ernest & Mabel* and arrived in 2002.

Mackerel fishing is a popular excursion.

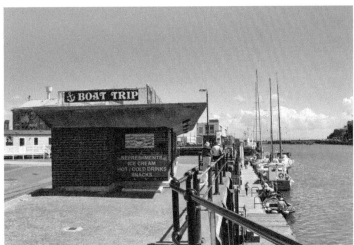

This was the Cosens landing bay.

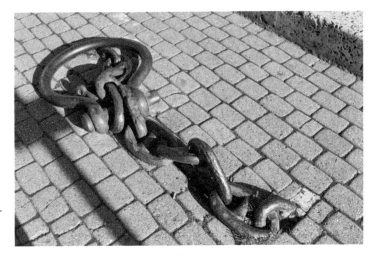

These chains were used to moor the large steamer vessels – this chain dates from around the 1880s.

Cosens Quay.

Cosens Quay.

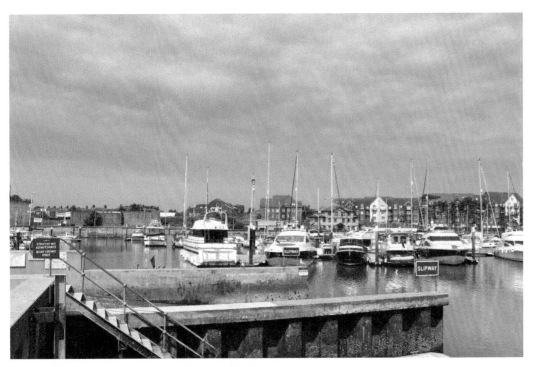

Cosens Quay – the slipway used by Cosens.

Cosens Quay.

BREWING

One industry that witnessed Weymouth's development from a small backwater to a successful watering place was the brewing trade.

Weymouth was an ideal place for brewing as there was a freshwater spring at Chapelhay and fields of barley at Radipole. The first evidence of brewing is within the account rolls of 1242–43. Fines were levied against twenty-four cases of 'breaking the assize of ale'. Regulations linked the cost of ale to the current price of barley and that the correct permission was sought to brew and sell ale.

As early as 1742 there was a brewery in Hope Square. John Flew leased a piece of ground 'on which heretofore stood a Brewhouse'. The Devenish family took over the site in the 1820s. There were two other breweries in Hope Square: Davis Brewery and John Groves & Sons Ltd.

After the boom of the late nineteenth century, the brewing industry started a period of decline. Davis Brewery ceased working in the early nineteenth century, but the other two continued to operate in competition. In spite of the business rivalry, Groves came to the aid of Devenish when the latter's brewery was badly bombed in an air raid of August 1940. The brewery was repaired using original materials.

During the interwar years beer output from the UK nearly halved, as did consumption. There were waves of takeovers and mergers as brewers sought to maintain or increase their market share. As a result, the number of breweries in England fell from 1,324 in 1900 to 141 in 1975. Groves was incorporated with Devenish in 1960. Devenish ceased brewing operations in the town on 12 November 1985.

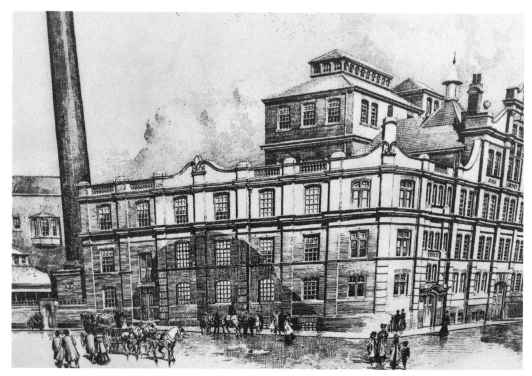

Brewers Quay in the eighteenth century.

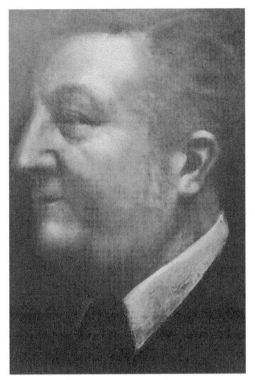

Above left: James Aldridge Devenish
(1808–71). He was a partner in the
brewery. He was also three-times Mayor
of Weymouth.

Above right: John Herbert Clark
Devenish, the grandson of James. He
became a partner in 1885.

Right: Sir John Groves (1828–1905). His
father brought Luckham Brewery in
1840 and put him in charge in 1854. He
was Mayor of Weymouth in 1886–89
and was the last man to be knighted by
Queen Victoria in 1900.

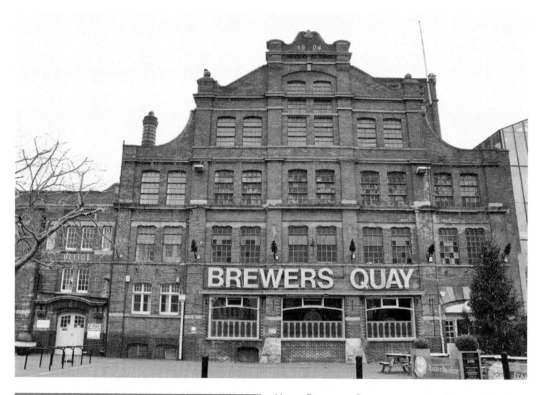

Above: Brewers Quay – once the heart of the brewery trade in Weymouth.

Left: The back of Brewers Quay.

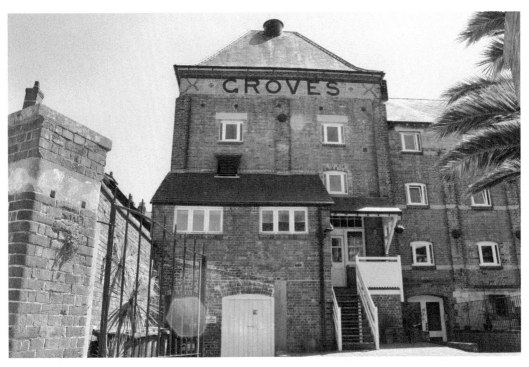

Groves brewery.

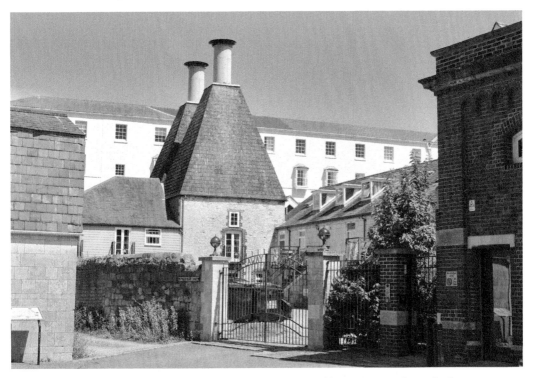

This area would have once been filled with the aroma of hops emitting from the brewery.

The old stables have now been made into desirable homes.

Houses built for the brewery workers.

Following its closure, Devenish and Weymouth & Portland Borough Council launched a major plan to transform the building into a shopping centre. Devenish spent £4.5 million on refurbishing the building. It opened in June 1990 and was a huge success, being heralded as the 'Covent Garden of Dorset'. The building also housed the award-winning and much-loved Timewalk exhibition and Weymouth Museum. In 1992, a hands-on science centre named Discovery was also opened.

Despite the success of the new shopping centre, Devenish suffered operational losses and ultimately decided to sell the building. A succession of owners followed. Faced with increasing costs and losses, the site was sold to a local investment group, Brewers Quay Investment LLP, in 2010. By the end of the year, much to the shock of many locals, Brewers Quay was closed as there were plans to convert it to a hotel and apartments. But it was not to be, as in 2011 the group decided the plan was not viable. In March 2013, Brewers Quay reopened primarily as an antiques emporium, holding approximately fifty traders and Weymouth Museum. Unfortunately, though, it was nowhere near its former glory.

In 2016, yet again the building was sold. This time to Versant Development & Homes, who announced their intentions of redeveloping the building. Work began in 2018.

Whatever happens in the future, the building itself will survive as an important feature of the townscape.

WYKE REGIS AND WHITEHEAD

Wyke Regis is a village that used to be 1½ miles south-west from Weymouth, but with modern development the two have now merged together. Farming and fishing were the mainstay of the village until the twentieth century.

Manor Farm was built around the same time as the church. The farm employed many villagers and its activities were centred on providing for the village. It continued as a working farm up until the late 1980s.

The hub of village life in Wyke Regis was always the square, where many of the residents lived. In 1891 the arrival of a new factory changed the landscape of this small village.

Robert Whitehead was a Lancastrian, born in 1823, who trained as an engineer. He developed the first effective self-propelled naval torpedo. His company, located in Austria, was the leader in torpedo development. The British Navy became interested and encouraged Whitehead to set up a manufacturing facility in England.

The newly constructed Portland Harbour was already a site for testing torpedoes and Whitehead decided it was an ideal place for his factory. He purchased an 8-acre site at Ferrybridge, Wyke Regis. In April 1891, the foundation stone of Whitehead's factory was laid down by Lady Countess Hoyos.

The arrival of the factory resulted in an influx of skilled tradesman and engineers. These incoming workers need places to live and over the next few years streets of red-bricked terraces began to be built alongside the old cottages of Wyke, as well as new pubs, schools, shops and clubs. It quickly became a key employer for Weymouth. Even royalty came: Edward VII visited the works on 4 April 1902.

Robert Whitehead retired at almost eighty years old, leaving an established Ferrybridge Works. His eldest son, John, took control in the late 1890s. During the next two years the company grew, with orders from America for torpedoes.

In 1906, Vickers and Armstrong-Whitworth & Co. acquired sufficient shares (the rest of the shares were with the Whitehead family) to take control.

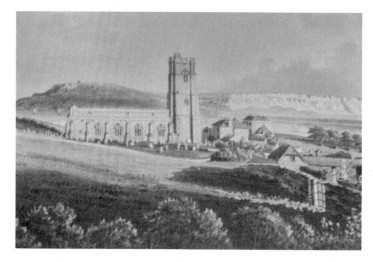

A church has stood on this site, with its commanding views over Chesil Beach, since as early as 1172. Painted by John Upham, 1821.

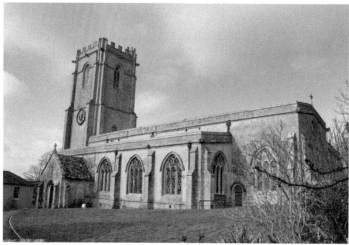

The church tower can be seen from some distance and has long been a landmark to mariners.

In the churchyard many victims of Weymouth's most famous shipwreck, the East Indiaman the *Earl of Abergavenny*, lie buried. The ship sank in Weymouth Bay in 1805 with the loss of hundreds of lives, including its captain, John Wordsworth, brother of the poet William Wordsworth.

Manor Farm was renovated and the old barns became houses.

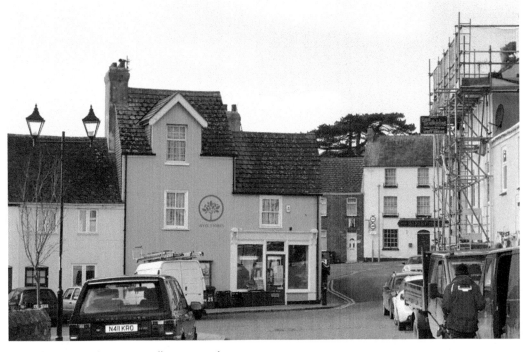

The general store is still in use today.

Left: The remains of the old horse trough. It used to be said that unless you had fallen in the trough, you were not a true Wykite!

Below: The Fleet.

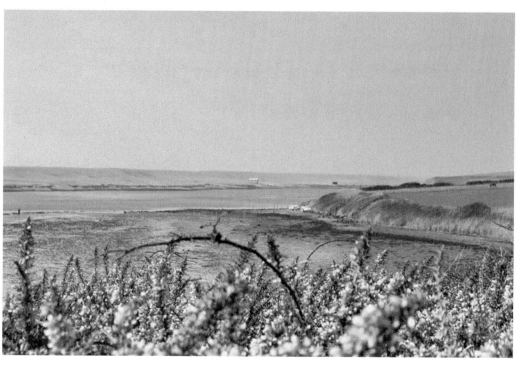

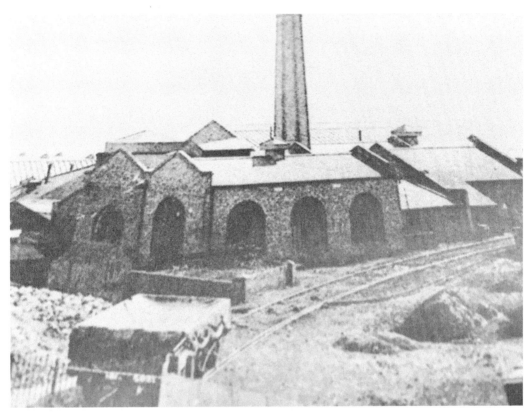

Whitehead's factory.

Whitehead's original foundation stone.

Left: The remains of the Whitehead pier – at low tide you can still see the pier stretching out into the sea where testing took place.

Below: The memorial hall in Wyke Regis, which is on the site of the old school that Whitehead built for their workers' children.

Robert Whitehead passed away on 14 November 1905 at Shrivenham, Berkshire, aged eighty-two. His engineering achievements and influence on naval warfare were largely unacknowledged by the British government, which *The Engineer* drew attention to in his obituary: 'Mr Whitehead is reported to have considered [the torpedo] as a means for ensuring peace rather than bringing war … His idea, no doubt, was of the fearful effects of the torpedo, once realised, would be a sufficient deterrent to peoples and nations contemplating war.'

It seems that Whitehead was a pleasant man: 'much loved for his courtesy and benevolence,' according to the obituary. 'There is reason to believe he felt acutely that, though honoured by other countries, the country of his birth did not regard him in the same manner,' but 'he was the most modest and retiring of men and did not seek public fame for himself.'

After a lifetime of engineering, his accomplishments are summed up by his Berkshire tombstone epitaph inscription: 'His fame in all nations round about.'

Following Whitehead's death in 1905, Armstrong-Whitworth & Vickers Co. took over the factory.

At the outbreak of the First World War in 1914, the British Admiralty took complete control of the works with round-the-clock production.

Once the war ended in 1918, Vickers-Armstrong were handed back control. The orders coming in started to slow down; it was such a dramatic turn of misfortune that in 1921 the Whitehead Company went into liquidation, sacked its workforce and closed the gates. By late 1923, however, it was a newly formed company: the Whitehead Torpedo Company Limited. They brought the majority of the Wykes Regis site for a reported sum of £17,700.

Many of the old workforce returned, but also – and most importantly – young blood came in. Younger men came to start their careers in numerous areas of employment. A new concept of torpedo was designed. One dropped from a plane, called the Whitehead Aeroplane

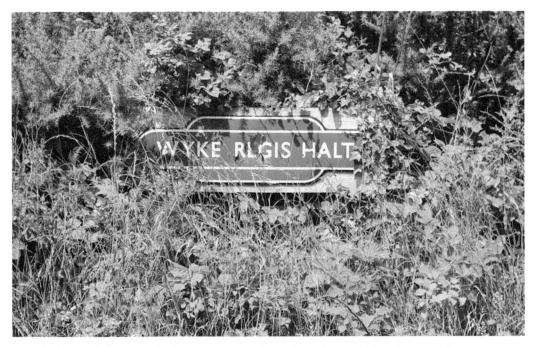

In 1909 a halt was built that was accessed by a long footpath from Ferrybridge cottages, an estate built for workers. Surprisingly this had not been done before.

Left: The platform was lengthened in 1913 during the First World War. When the factory was at full production over 1,000 workers used it a day.

Below: Whithead's may now have gone, but the old rail track is still here – now a 2-mile cycle and footpath. This picture shows Rodwell staion, which was often described as one of the prettiest stations.

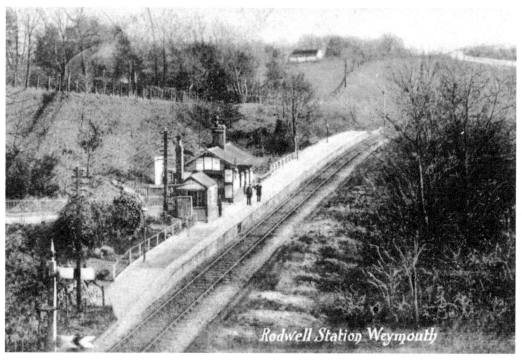

Rodwell Station Weymouth

Torpedo. At over 16 feet long and 18 inches in diameter, they could be dropped at a height of 140 feet at a speed of 105 mph.

But then came the Great Depression in the 1930s. Whitehead workers went on a three-day week, but apprentices were still on full time.

Torpedoes occasionally went astray. In 1933 a 30-foot-long torpedo sped through the sea and ended up whirring up Greenhill Beach with its propellers spinning. Luckily it did not hurt anyone.

At the outbreak of the Second World War over 1,500 workers were employed at the factory. Women were drafted in to replace the skilled men who had been sent into the armed forces The importance of the torpedo meant that the factory was liable to enemy air attack, and on 1 May 1941 the factory received its first direct attack. The bomb and machine-gun fire from the enemy plane caused considerable damage; two lost their lives and many more were wounded.

Production was quickly resumed. Nonetheless some aspects of the torpedo manufacturing were moved to other locations, so as to ensure a steady supply of torpedoes.

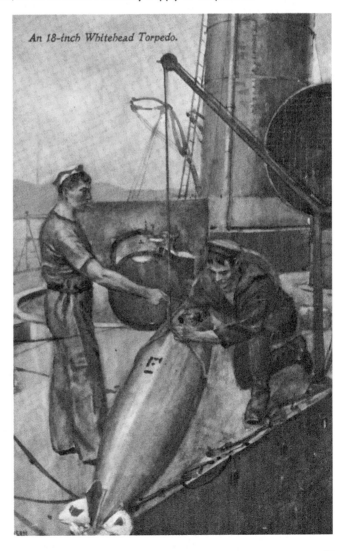

An 18-inch Whitehead Torpedo.

The Royal Navy postcard of a Whitehead torpedo.

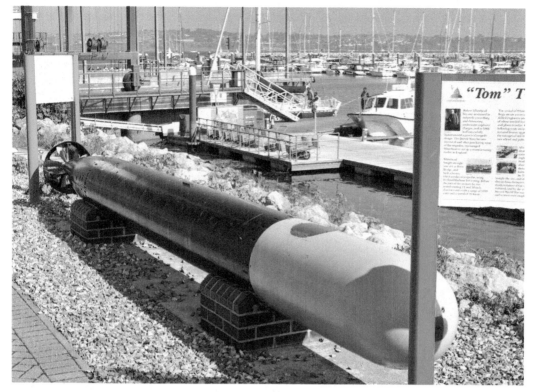

Tom the Torpedo – displayed at the Sailing Academy. The Mk 8 torpedo was the common submarine torpedo in use during the Second World War.

Even during the war, team spirit was a high priority. There were numerous sporting events and entertainment organised, especially pantomimes.

As the war neared an end, the need of torpedoes reduced. Among some of the alternative peacetime contracts won was making machines for packaging soap, cigarettes, ice cream, soap flakes and butter. Pumps were made for oil and petrol, oil separators for Norway and even John Smith brewery of Todcaster had stainless steel vats made. The Viscount aircraft had the intricate flap gear box and undercarriage pistons cylinders made. During this time, the British Admiralty decided to launch a new torpedo research programme.

Early in the 1960s, torpedoes were still being produced (although a small amount now), and in 1962 Vickers-Armstrong (Engineers) based in Itchen, Southampton, had amalgamated with Vickers-Armstrong based in South Marston near Swindon. They became known as the Vickers-Armstrong (Engineers) Ltd, and was the catalyst to a reorganisation of Vickers-Armstrong in 1966 after developing the Accelerated Freeze Drying Process for food and the Hovercraft. The Vickers-Armstrong Group decided to sell the Ferrybridge Works (at Wykes Regis), transferring many of the workforce to South Marston, which was to have a £300,000 investment programme for their Hydraulics Division.

The Weymouth Works closed and its workforce of 900 employees were offered to transfer to Swindon. On 31 March 1967, a conveyance was signed by Vickers Ltd to sell the Ferrybridge Works to a company called Wellworthy Ltd, thus ensuring that there would be employment for the engineering-skilled people of the area.

Many of the Ferrybridge Works employees decided against moving to Swindon and took redundancy instead. Some were immediately re-employed by Wellworthy Ltd – a total of 100 staff took employment with Wellworthy Ltd out of 148 employees on the Vickers books

The new company had to repair and demolish quite a lot of the Ferrybridge site as it had deteriorated before they could start production. Wellworthy main production was machinery for the motor industry. By 1986, the Ferrybridge workforce was around 350.

Although a great deal of change occurred over the next few years, the Ferrybridge Works sadly closed.

In 1997, after 106 years, the old factory was demolished to make way for a housing development. The original foundation stone laid in 1891 was found and can be seen today, but unfortunately the original 'time capsule' that was laid with it has still to be found. If you are lucky enough to discover it you will find three small coins, a Jubilee shilling and half-crown and copies of the *London Times*, *Evening Standard* and *Southern Times*.

All that is left of Whitehead's is this memorial stone.

SECTION TWO

PORTLAND – A BRIEF HISTORY

The Isle of Portland, 4½ miles long and 1¾ miles wide, is a defiant block of the Jurassic Coast, weathered by 100 million years of restless sea and anchored to the Dorset mainland by the thread of Chesil Beach.

Portland is thought of as an island, although this isn't wholly correct in the true sense of the word as it's reached over a causeway from Chesil Beach. It is a block of limestone just 4 miles long by a mile and a half wide at its broadest point. The Isle of Portland provides one of the most dramatic coastal landscapes in Britain. Thomas Hardy described it as the 'Gibraltar of Wessex'. It is known by many for Chesil Beach – a pebble beach 18 miles long that stretches north-west from Portland to West Bay. For much of its length it is separated from the mainland by an area of brackish water called the Fleet Lagoon.

There are few places in the British Isles with such a unique story as Portland. Every age has left its mark. The Romans had a name for it: Vincelis. According to the Anglo-Saxon Chronicle the Vikings' first raid on English soil was here in AD 789.

Portlanders were traditionally fishers and farmers. Portland was the first Dorset entry in the 1086 Domesday Book. Portland has been a royal manor for more than 1,000 years and throughout that time its court leet has guarded the rights and privileges of the islanders. This ancient body still sits.

In 1588, the Spanish Armada passed nearby and a great battle was fought off Portland Bill. During the British Civil War, Portland tried valiantly to hold out for the king against Cromwell's troops, but Portland Castle was eventually captured in 1643. When the monarchy was restored in 1660 Charles II rewarded Portland's loyalty with special grants and rights, which have been renewed by every succeeding monarch.

Increased shipping in the seventeenth to nineteenth centuries led to innumerable shipwrecks on the island shores, especially on the notorious Chesil Beach. Even after the erection of the first Portland Bill lighthouse in 1716, ships cargoes and lives were lost on an appalling scale.

Before the construction of the first bridge in 1839, the only connection between Portland and mainland England was a small ferry that used ropes to cross the gap. Traditionally, very few Portlanders had the need or desire to leave the island and it remained for centuries an isolated community and many old island customs survived here until the twentieth century.

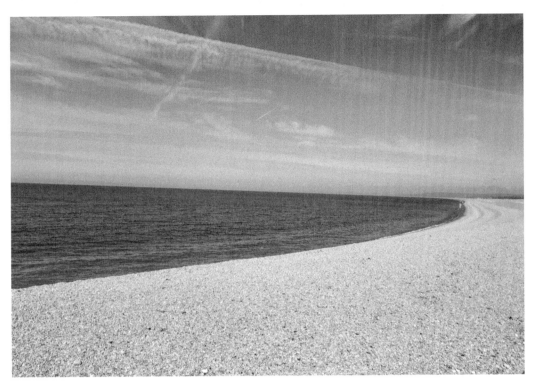

The stunning Chesil Beach.

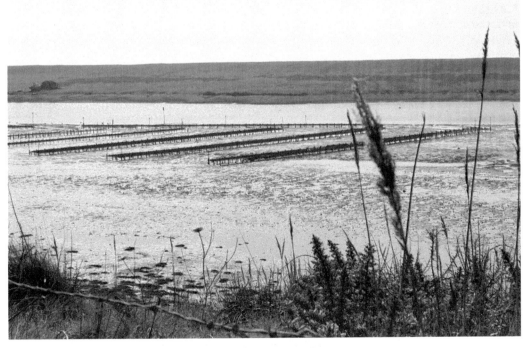

The Fleet – in this photo it is being used for oyster farming.

Historically, inhabitants thought of themselves as not-quite English – mainlanders weren't trusted and were called Kimberlins (strangers). Thomas Hardy described Portland as the 'Isle of Slingers', repeating stories of Portlanders throwing stones to keep Kimberlins away.

In this section of the book I am going to look at the fishing and farming and how the traditional life of Portland was rocked to its core when Portland stone became the material of choice for seventeenth-century architects. I will also be looking at the nineteenth-century Breakwaters, which was one of the greatest engineering projects ever undertaken in England and led to the development of the Royal Naval Base here. Finally, I will look at the origins of the prison population and how that has evolved over the centuries.

FISHING AND FARMING

Agriculture was central to Portland's early self-sufficiency. The limited land area and resources meant the islanders, like many medieval communities, devised a communal farming system based mainly on sheep and corn. This was strictly controlled with various procedures being enforced by the island's local governing body, the court leet. Common crops were grown in particular areas and that crop harvesting and the grazing of animals was carried out on a communal basis. Maps from the eighteenth and nineteenth centuries show eight arable fields on the island. These were each divided into numerous strips. These narrow strips of land were known as lawns. These were grouped in small numbers and divided from one another by baulks of unploughed turf known as lawnsheds. Some of these strips are still used today.

The fields were worked by women. Portland women had rights unequalled elsewhere in England. They could own and inherit money separately from their spouses.

One of Portland's valuable assets was sheep. The breed was suited to the terrain by being small, hardy and agile. Both sexes were small-faced and small-horned. Ewes could lamb up to three times a year. The wool was fine and close, resulting in a significant local wool trade. The mutton was regarded as the best in the England – and a favourite of George III.

A big event was washing the sheep before sheering when the flock was taken down to the mere, thrown into the gut and made to swim across the narrow creek.

Although more sheltered parts of the island had some trees, wood for fuel was always scarce. The islanders burnt dried cow dung mixed with straw.

By 1800 quarrying was consuming over 20,000 tons of stone a year, but Tophill's landscape was still dominated by farmland rather than quarries for next 100 years.

Chesil was traditionally a fishing community, with fishermen operating and launching their boats from Chesil Cove. Since at least the seventeenth century, boats known as Lerrets were the primary type being used there. The Lerret was a boat unique to Chesil Beach, and was ideal for the conditions. They were 16 to 17 feet long and 5 to 6 feet wide. They were flat-floored with a sharp bow so they could be hauled to the top of the beach. They would then be launched at the top of the beach and then speed up before entering the water – a bit like a rollercoaster today. It would have a crew of around six oarsmen. The men rowing would sit midship and the seat aft would be taken up by the seine.

The seine was netted and loaded with stones one side and corks the other, allowing the lower edge of the seine to the bottom of the sea and the corks fastened to the top rope kept the net upright.

The fishing crews would often have to leave early and it was often the job of a young lad to be a 'knocker upper' – the knocker consisted of a 10-foot length of bamboo with a lump of lead on one end. A piece of cloth was then wrapped around the lead to prevent breaking

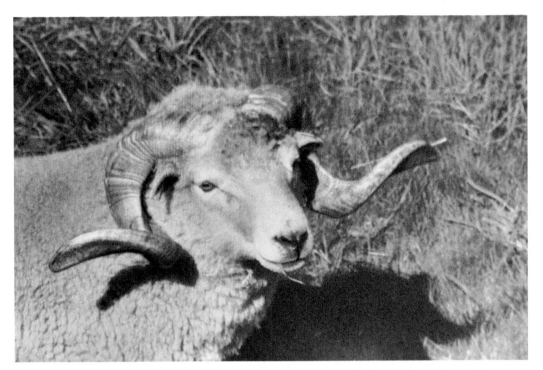

Portland sheep. Today the only place you can see this breed in Portland is at Fancy's Farm.

windows and then the boy would knock on the bedroom window of the crew member he was trying to wake.

If fishing season was good the locals held a May Day tradition to celebrate on Chesil Beach with singing and dancing. Sticky buns were suspended between two oars and hands were tied behind backs as they tried to bite the buns.

Fish were sent as far as Southampton and London. Daily catches of up to 270,000 mackerel a day were known. But after living costs rose post-1850s it became difficult to support a family through fishing alone. Some fisherman tried drastic ways of increasing a catch by using dynamite underwater stunning the mullet and bass and then gathered them up, but the practice was banned by an Act of Parliament.

Fishing declined in the 1930s, as West Bay was designated a bombing range in 1935, which closed off miles of Chesil Beach to the anger of many fishermen. The trade never recovered.

Another way to boost income was smuggling. In the eighteenth century the Napoleonic Wars forced up prices of continental wheat and liquor to an unaffordable level. Smuggling became an irresistible way of making quick cash. Daniel Defoe stated, 'the reigning occupation from the Thames to Lands End is roughing and smuggling.'

In the late and eighteenth century more people from Portland were committed for smuggling offences than any other part of Dorset as it had natural landing places. Smugglers had the unique advantage of Chesil Beach and the Fleet.

Smugglers landing on the beach in the pitch black of a moonless night were able to judge their position by simply picking up a handful of shingle and gauging the average size of the stones. At the Portland end the pebbles are the size of potatoes and then progressively slim down to pea-shingle on the beach at Burton Bradstock.

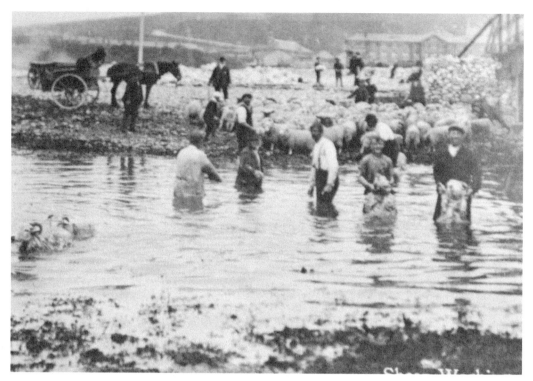

Sheep dipping at the Mere, 1910.

Lerret.

Visitors or fisherman wearing their Sunday best, posing by a Lerret.

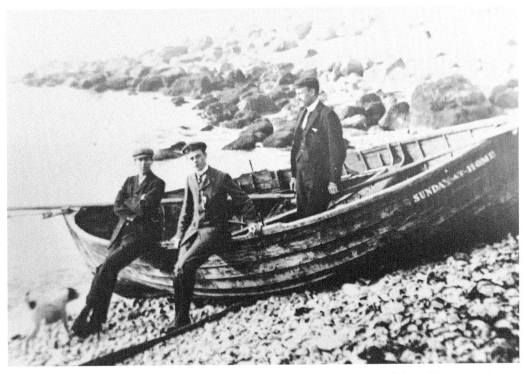

The Lerret had unusaul oars as they were used to pivot the boat and thus able to use the net without manning the boat.

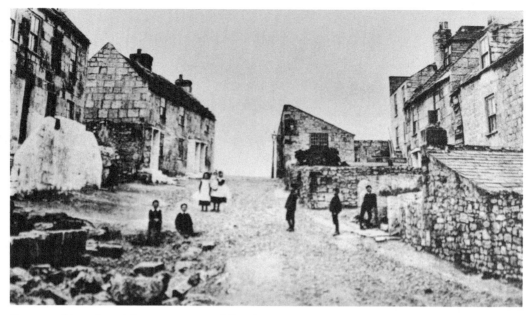

Because of its vulnerability to storms and flooding, many of Chiswell's original cottages were built on or against the pebble bank of Chesil with their own floodways and cellars.

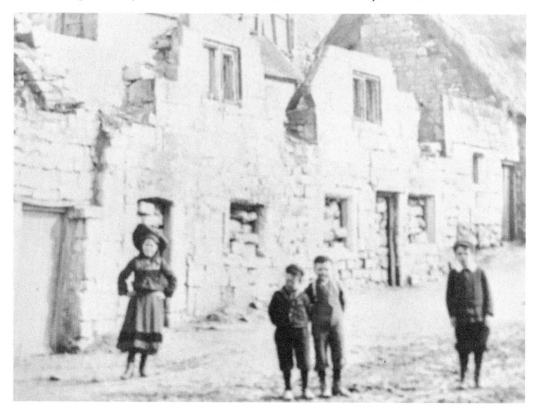

Children roaming around Chiswell streets.

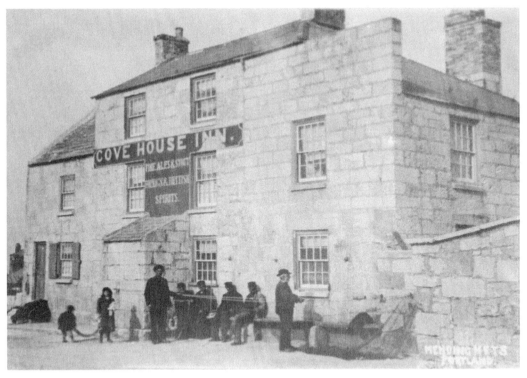

Fisherman mending his net outside the Cove House Inn.

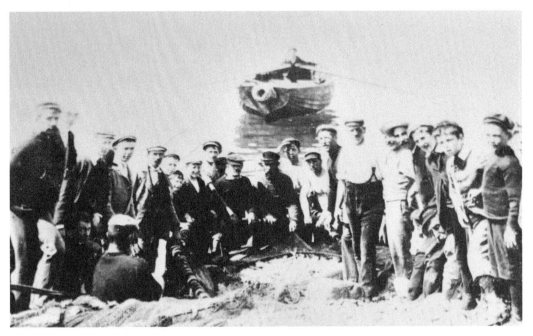

Celebrating a good day of mackerel fishing.

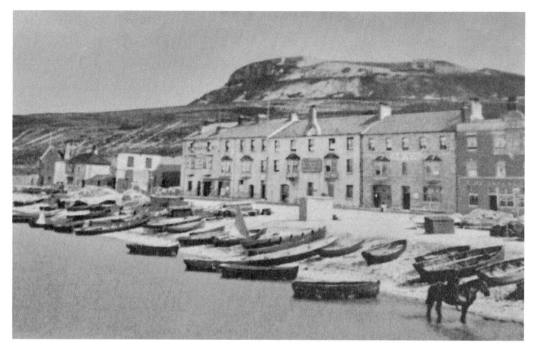

Castletown with Lerrets on the beach.

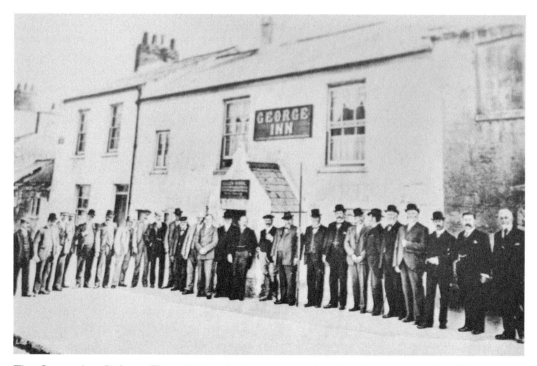

The George Inn, Reforne. The pub has also been reputed to have been a smugglers' haunt, with suggestions made of tunnels leading to the cliff and St George's Church. It was also favoured by prison officers!

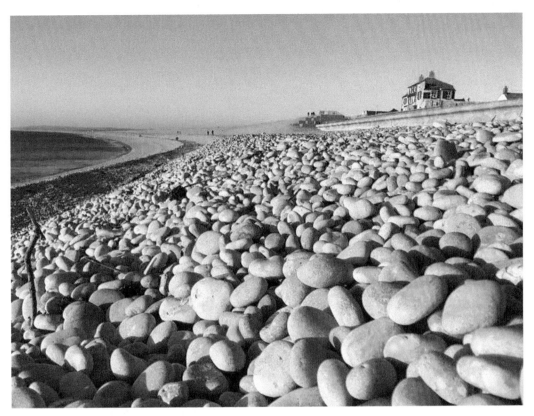

Pebbles on Chesil Beach.

Tubs landed here were humped over Chesil Beach and sunk in the quiet waters of the Fleet. This was known as sowing the crop, and the smuggler could go and harvest at a more convenient time.

Cottages throughout the island had cellars and tunnels running underneath. It was not unknown for the kitchen flooring to collapse to the cellar below. Night-time signals were by means of fires or lamps on the clifftops. Women played an important part in distribution by hiding silk, lace and even spirits under their skirts. One such lady was Catherine Winter, a seventy-year-old Weymouth seamstress who was sentenced in 1844 for smuggling. And then again aged seventy-three!

Portlanders had a reputation for luring ships to wreck to plunder, but there is little actual evidence of this. They would, however, take from unfortunate sea wrecks. Chesil Beach and the cove have seen many shipwrecks, more so than most other parts of the British coast. The beach forms an extended lee shore during south-westerly gales. It was often the case that a ship attempting to round Portland Bill and reach the English Channel or Britain found that the wind and tide would push them into Lyme Bay, towards the beach. Thomas Hardy called the area 'Dead Man's Bay'. It's a fitting name because there are some 200 wrecks in the bay.

One such case was the floundering of the *Royal Adelaide* on the night of 25 November 1872. The vessel, carrying sixty-seven passengers and crew, bound for Australia, was caught in a storm and became trapped in West Bay when her anchors dragged in the swell. The life-saving

A Portland dog. With webbed feet, they made good swimmers. They were specially bred to recover contraband, but are now extinct.

crew were eventually able to get a line aboard and were able to rescue sixty in total before the line snapped, leaving a handful of passengers to be washed overboard and drown, including a six-year-old girl called Rhoda Bunyan.

A gigantic wave broke the vessel in two, spilling out her cargo. Hundreds of barrels of rum, brandy and wine came rolling ashore. Within hours thousands of people from Portland and Weymouth came to the beach to plunder. Coastguards and soldiers from the Verne tried to control the crowd, but they were met with contempt. All the cargo was quickly spirited away. This opposition from the Portlanders came as no surprise to the customs authorities, who were reluctant to visit the island 'for fear of being struck in the head by a volley of stones'.

PORTLAND STONE

All around the world Portland is known for its wonder stone. This great slab of limestone was laid down 145 million years ago in the late Jurassic period when dinosaurs roamed the land. West Britain was further south then, approximately the same latitude that Morocco is today. The climate was warm and the limestone formed in layers under the shallow sub-tropical sea. It is packed with shells. Above it lies the Fossil Forest and rocks that formed in salt flats and lagoons. Dinosaurs walked their shores.

The stratum from which Portland stone is obtained constitutes the uppermost division of the Jurassic system and forms the foundation upon which rests the freshwater limestone of the Purbeck beds. These beds consist of 'topcap' and 'skullcap', producing a stone unsuitable for building that is fit only for rubble and concrete.

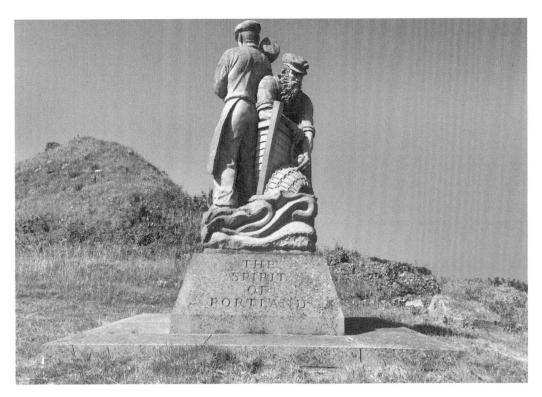

Above: Monument to Portland stone.

Right: Welcome to Portland monument – made from old equipment from the quarries.

A fossilised tree.

Next is the roach bed. This is an oolitic limestone and is usually made up of casts of shells and cavities formed by the decay of marine organisms. Commonly known as 'Portland screws' and the 'horse's head'. It is suitable for many types of building work such as plinths, rock-faced work and bridge work.

Whitbed lies under the roach, and it is from this limestone that the well-known Portland stone is obtained. It is a light-brown colour and contains numerous shelly fragments, which gives it its unique appearance.

Basebed is the bottom oolitic tier. It has a different quality depending on which part of the island it is from. A good hardstone of even texture, it is suitable in every respect as a first-class building stone. It is often difficult to distinguish from the finest Whitbed, and is often preferred.

There is evidence that the Romans used Portland stone.

The quarrying of stone for local use had gone on from early times, certainly at the beginning of the fourteenth century Portland stone was being used at Exeter Cathedral.

It was during the reign of James I that really extensive use of Portland stone began. It was employed in the building of the Banqueting House at Whitehall and in other public and private buildings in London.

The demand for Portland stone was greatly increased after it was used for rebuilding works after the Great Fire of London in 1666. Christopher Wren was appointed as commissioner for rebuilding the City of London and Portland stone was used in rebuilding much of the city, including in St Paul's Cathedral and many of the churches.

The greatly increased use of Portland stone during the seventeenth century brought considerable employment and prosperity to the island, but also led to tensions.

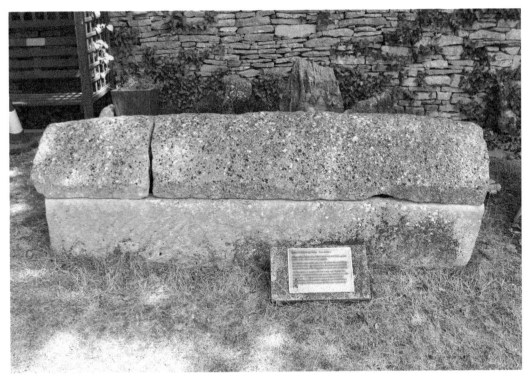

A Roman coffin found on Portland. (Photo taken at Portland Museum)

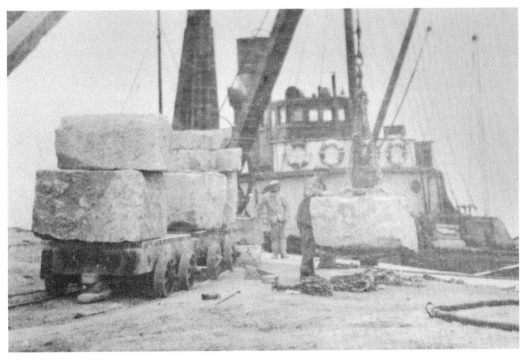

Stone being packed onto a barge heading for London.

An ancient custom of the manor of Portland imposed a levy of 1s per ton on all stone exported out of the manor and the proceeds were shared between the Crown and the tenants. Stone for use of the Crown did not, however, have to pay any duty. In 1675 Charles II granted to the dean and chapter of St Paul's the right to raise stone on the island for use in their new cathedral, which came within the category of stone for the kings own use. The islanders were not happy. In March 1678 a complaint was made to the king by Thomas Knight:

Deputy Guardian of the Quarries that John Hyne of Southwell, Edward Pearce of Southwell, Abel Sweet of Wakeford and Edward Pearce of Easton have gathered together Multitudes of unruly persons, and have gone at the head of them and Encouraged them to Commit several insolence and disturbances ... unhorsing and overthrowing the carts and carriage and spoiling the ways, Piers and Cranes to the great discouragement and hinderence.

Knight went on to claim that the unruly persons had broken his carts and scattered the pieces above a mile distance from each other due to the islanders objections to the removal of the stone for the king's use without paying the customary levy.

The king summoned the troublemakers to appear before him at Whitehall. Upon their humble apologies and promises to behave themselves in future, they were pardoned and dismissed.

However, the issue was never really resolved and arguments over the rights of tenants continued to flare up during the time it took to complete the cathedral. On 12 May 1705, Sir Christopher Wren wrote a sulky letter to the quarrymen where he criticises the demands of the tenants and claims that they have no rights to the stone. In spite of this, the tonnage money continued to be paid.

All tenants of the manor had the right to open quarries in the common lands of the manor upon payment of the customary dues for stone taken. But the business of quarrying was expensive since the best stone lay at considerable depth and large quantities of rubble had to be moved before any return could be obtained. It required a large capital expenditure on equipment and labour, therefore the trade was dominated by a few large undertakings. The largest purveyor of stone in the seventeenth century was Thomas Gilbert. He died in 1704. In 1705, when his wife Elizabeth died, Edward Tucker of Weymouth was her executor. The Tucker family dominated the stone industry in the eighteenth century and became allied to another important family: the Stewards. The Tucker Stewards continued to control the bulk of the trade during the early nineteenth century.

The early nineteenth century saw around 20,000–30,000 tons of stone annually exported. Around 800 men and boys, 180 horses and fifty ships were engaged in the stone trade. In 1839 the parliamentary commissioners reported that the annual export was 24,000 tons and there were fifty-six quarries with 246 quarrymen continually employed.

The weares were an important aspect of the industry. As the marketable stone was covered to a depth of at least 8–10 feet of rubble, a dumping place was very necessary.

As quarrying extended inland away from the cliffs, the weares became less important as land from which the stone had already been quarried could be used for dump in the rubble.

The piers from which the stone was shipped were also, of course, very important. As quarrying moved inland it was necessary to carry the stone further for shipping. The business of getting the stone to the piers was difficult and laborious due to the poor state of the roads and the steepness from the land to sea. Blocks of large stone were placed onto wooden carriages with wheels and then two horses were harnessed in the front. One or two behind had to act as brakes – it was all very distressing for the animals.

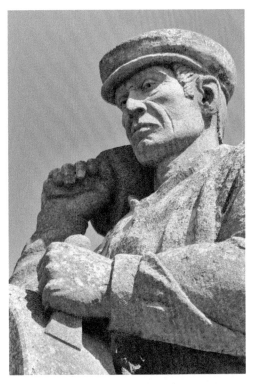

Sculpture of quarrymen.

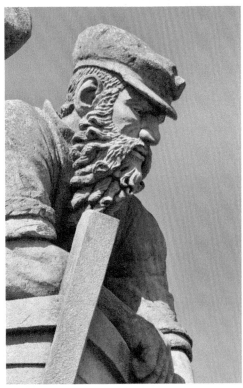

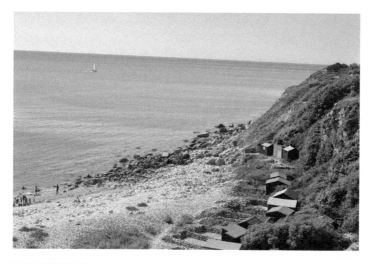

This page and opposite: Images from across the island of dumping stone.

Left: The coast path walk around Portland overlooks the Weares.

Below: Revd J. Skinner, visiting in 1804, described how the poor horses suffered great cruelty pulling the stone. This led to a call for a railway.

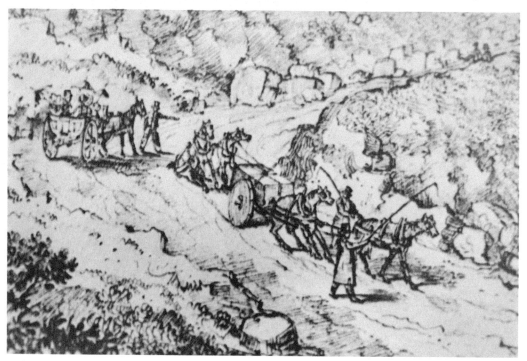

It was not until 1826 that Merchants Railroad opened to transport the stone to the piers. It ran from Priory Corner to Castletown. It was owned by a number of quarry owners, led by the Steward family, and was designed by James Brown. Its complete length was approximately 2 miles. The blocks were loaded onto low wooden wagons at the quarries and hauled to Priory Corner, at first by horses and then later by traction engine. Then the stone was reloaded onto Merchant Railways wagons and hauled by horse to the top of Merchants Incline. The horses were then unhitched and wagons hooked onto a chain. The other end of the cable was attached to an empty wagon at bottom of the incline in Castletown, and gravity then took charge. At Castletown the horses pulled the wagons out to the piers where the stone was loaded onto ships and barges. Further additions were added to the line during the nineteenth century, providing a network of horse-drawn tramways to serve the ever-expanding quarries of the island. The railway remained in use until 1939.

Quarrymen worked in gangs of six or seven with a boy to each crane. Clothes would be a pair of long trousers, heavy hobnailed boots and a knit jacket. Lunch would be carried in a large handkerchief and consist of bread, butter, cheese and a quart of cold tea or ale. They were paid piecework rates on the tonnage of stone obtained – known as 'winning the stone'. For monetary reasons, gangs were often made up of family members.

For centuries quarrying relied on brute force and hard work. First, the overburden had to be removed. Following this came the cap. To do this, 12-foot holes had to be drilled by a gang of three men – one holding the drill and the other two working in time with an 18-lb sledgehammer. It could take all day to drill one hole and twelve holes might be needed before explosives could be used. Then came the roach layer. Whitbed lies under the roach and this is where the well-known Portland stone is won. Quarry songs were often sung to keep the rhythm of hammering. The stone was then cut into blocks along naturally occurring faults.

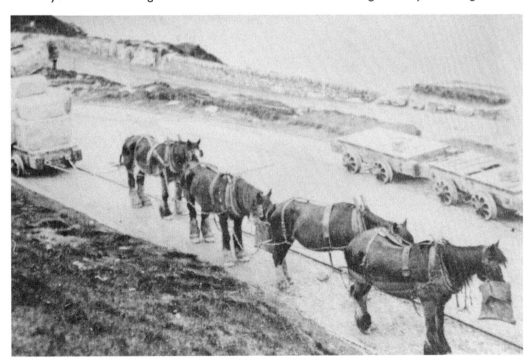

Horses waiting to pull the stone.

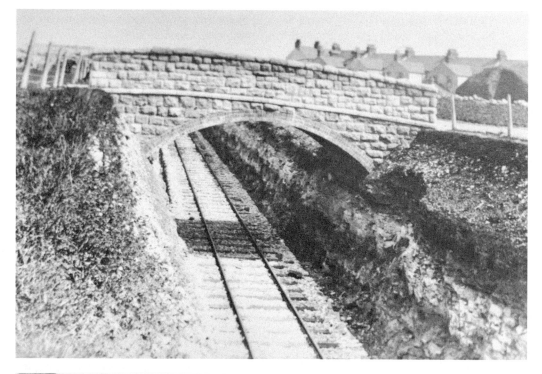

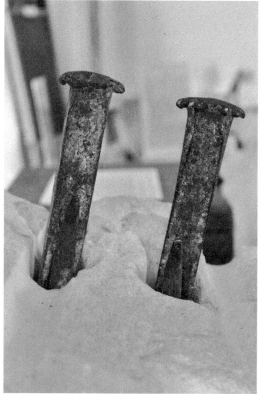

Above: Merchants Railway. Today this is a popular walking track.

Left: Tools of the trade. (Photo taken at Portland museum)

Although five-and-a-half-day weeks were worked, there were lost days to weather and accidents often occurred. One poor soul, Thomas Samson, was blown 15 feet into air, leaving a widow and fifteen children.

Money was only earned on useable stone and gang members normally had a sub until the last Friday of the month when the balance would be paid.

In 1887 Bath stone firms came to Portland and bought up local companies. United Stone Company was launched in 1909, buying out a number of Portland firms.

In the second half of the nineteenth century, and up to the First World War in 1914, the British Empire was at its peak. Portland stone was in demand for government buildings and quarrying spread rapidly across the top of the island. The building of a prison, breakwater and fortifications on Portland led to an enormous demand for Portland stone locally.

During the First World War the quarrying industry declined by two-thirds and the price dropped sharply. There was a bittersweet revival after the war as nothing but the best stone would do for the Whitehall Cenotaph, which was to be the national memorial to the dead. The order for the Commonwealth graves was an incredible challenge to the masons and between 1919 and 1932 some half a million slabs were shaped, carved with names and badges and shipped from Portland for planting on the Western Front. Large war memorials were sent to all corners of the earth, one being to the Australian memorial on which three Portland masons carved 10,000 names.

The depression hit Portland hard in 1933. The price of stone plummeted and 650 men were soon out of work. The industry responded to the slump with a series of mergers, with Bath & Portland Ltd and the South West Stone Co. emerging as the largest firms. The first sign of recovery was in 1935 with the building of the Tate Gallery and the University of London.

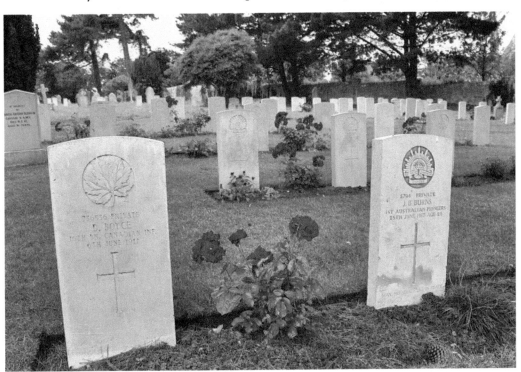

War graves craved from Portland stone. These graves are at Melcombe Regis Cemetery.

Another low came in 1937 when the governments great building plan for Whitehall was cancelled – Portland had pinned its hopes on this since 1912. One by one the quarries closed as orders dried up.

Then in 1945 war was declared. Many stoneworkers transferred to Wiltshire to construct underground ammunitions and more than 100 cranes removed for use in loading ammunition for Normandy.

The task of rebuilding the country after the Second World War brought twenty years of prosperity to the stone industry. Once again the island had the job of supplying gravestones for the nation's war dead and production of 500 a week rose to 1,000 in the early 1950s. By 1957 the final tally of headstones and large memorials fashioned by the island's masons and sent around the world was 800,000.

Despite labour shortages, vast quantities of building masonry were turned out to rebuild the cities hit by the Blitz – Plymouth, Bristol, Southampton, Manchester and London. Stone was exported to Holland and Belgium, and the biggest accolade for Portland stone was the order to face part of the United Nations building in New York. With so much work the attempts planners to control quarrying was seen as a hindrance. The authorities wanted to keep quarries 150 feet clear of roads, and the land to be reclaimed once the stone had been taken. The Bath and Portland stone firms objected to this and told a public enquiry in 1950 that they should be able to expand as much as possible. The ministry duly gave almost unrestricted planning permission, a decision which does not expire until 2042 and had a profound effect on the island's future.

Bath & Portland Stone Ltd took over rivals South West Stone Co. in 1960, and for twenty-three years dominated the island industry.

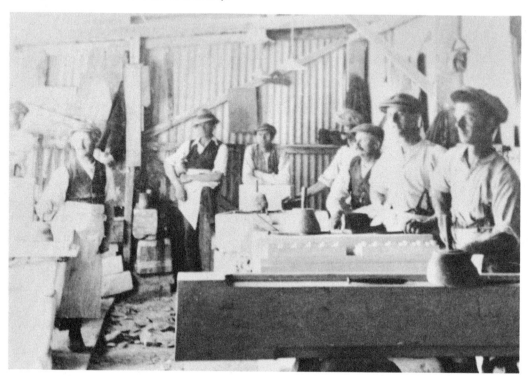

Masons – early twentieth century.

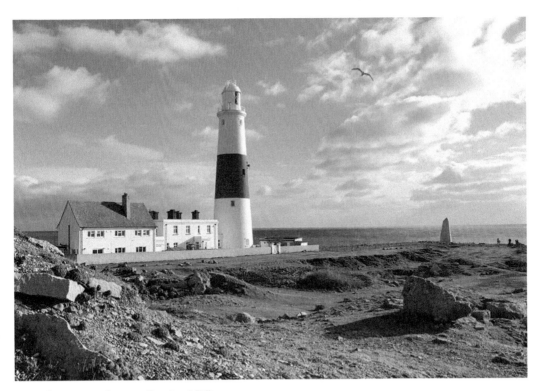

Quarrying close to Portland Bill.

In 1979 London-based firm Albion Stone came to Portland, and during the 1980s the use of Portland stone in modern architecture revived. The Hanson Group took over the old Bath & Portland Stone Group in the 1990s, but in 2004 the Portland side of their activities was separated out as the Stone Firms Ltd.

Technology has revolutionised quarrying on Portland. Mining is becoming more popular. Today Italian stone-cutting equipment designed originally for Tuscany's marble quarries are used. Diamond-tip chainsaws cut 20-ton blocks in twelve hours. A steel bag is then filled with water and inserted into gaps and pressurised to 300 lbs, which cuts the rock. A far cry from old.

In December 2000 one of the biggest controversies involving Portland stone occurred. The British Museum in London had spent £97 million to revamp a historic courtyard in the museum. Officials were confident that the 150-year-old Great Court would be beautifully set off by its new glass roof and a revamped south portico, splendidly restored with traditional Portland stone.

But heritage experts were aghast when the scaffolding around the portico was removed in December 2000 and exposed a shocking mismatch in colour between the new startlingly light-coloured stone and the much darker rest of the building. The alleged deception was embroiled in controversy as the museum's managing director claimed it had been deceived by a stonemason who used cheaper French limestone for the portico. English Heritage said its experts considered the work 'unfortunate, to say the least'.

Not all stone was exported out of Portland. In 1849 one of the largest ever public works in Britain began.

There is evidence of continuing quarrying dotted around the isle.

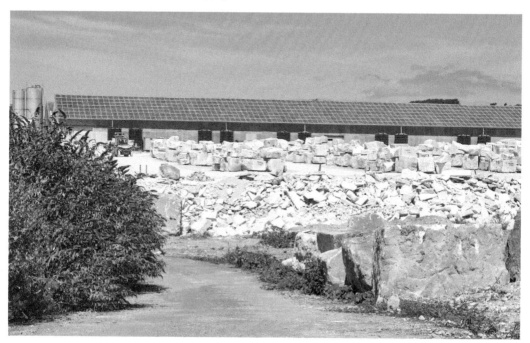

Quarrying firm.

Sign warning of quarrying.

A cement works on the isle.

Above: Some of the past quarries have been developed into nature parks. In Tout Quarry there are sculptures to wander around.

Left and opposite page: Sculptures.

Left: The old quarries are a wonderful place to explore. You can see from this photo the depth to which the land was quarried.

Below: A gullie man made by quarrying.

Right: A bridge made for the railway.

Below: Nature grows around the quarries.

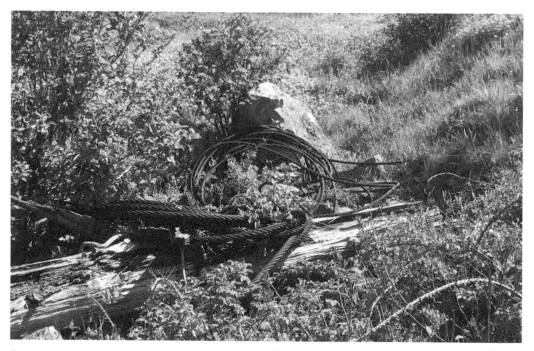

Evidence of the quarries' industrial past hidden among the flowers.

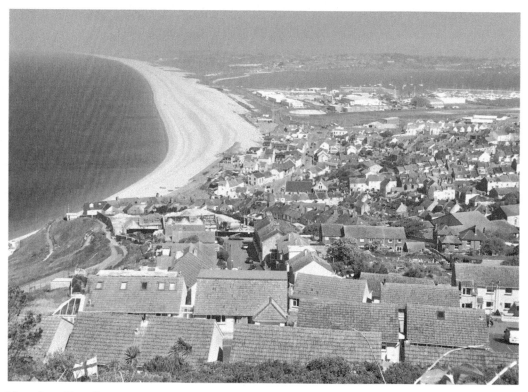

View from Tout Quarry.

THE BREAKWATER AND THE ROYAL NAVY

Since ancient times Portland has provided a safe haven for shipping. Protected on three sides, it provides a natural anchorage for ships.

In the sixteenth century Henry VIII realised that his new Royal Navy at anchor in Portland Roads were vulnerable to attack from the French or Spanish, so he commissioned the building of Portland Castle and Sandsfoot Castle to protect his fleet.

The Royal Commission for Harbours of Refuge (1844) concluded that Portland had the greatest strategic value of all possible harbour sites, and they recommended a breakwater to be built here.

The government acquired the whole of Verne Hill, East Weares, and land stretching to Priory, West Cliff and the Grove. Most of this was common land with islanders having historic rights to use it, where they could dig stone, pass on property etc. In July 1846 a meeting was held, with a crowd of 2500, a settlement of £20,000 was agreed to be shared between tenants and public works.

The sale of the Great Common meant the end of grazing rights. The face of Portland changed forever.

With the preliminary work beginning for the breakwater by 1847, potential workers were arriving from all over the country. By summer 1848 an extra 1,000 had been employed. New houses were being built with great haste at Underhill. Cases of drunkenness and assault also increased.

In November 1848 the Grove Convict Establishment opened to provide convict labour to quarry the millions of tons of that was stone needed to construct the breakwaters and the harbour defences.

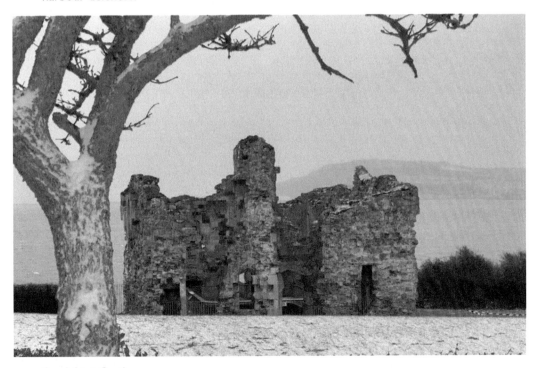

Sandsfoot Castle.

Construction of two breakwaters began when HRH Prince Albert laid the foundation stone on 25 July 1849. Designed by engineer James Meadows Rendel, the work was carried out under civil engineer John Towlerton Leather and John Coode as resident engineer. To construct the breakwater Rendel designed a massive timber staging supported on 33-metre-long piles screwed into the sea bed, guided into place by divers. This supported five lines of railways and the whole had to withstand storm conditions as it advanced 2 miles out into heaving seas.

Visitors came from far and wide to see the progress – Dorset's greatest tourist attraction by far. By the 1860s this was the country's most expensive public project.

Various defences were created to defend the harbour. The Verne Citadel, designed by Captain Crosman R. E., was built at Verne Hill between 1860 and 1881. The 56-acre fortress was designed for 1,000 troops and had gun emplacements facing seawards on three sides.

East Weare Battery was built during the 1860s along with the detention barracks East Weare Camp. On the inner breakwater was the Pierhead Fort, and on the outer breakwater the circular Breakwater Fort. On Weymouth's side of the harbour the Nothe Fort was built at the end of the Nothe Peninsula, which was completed in 1872. In 1892 the Verne High Angle Battery was built in a disused quarry near the Verne Citadel. East Weare Rifle Range was completed at the beginning of the twentieth century, while in 1905 the Breakwater Lighthouse was placed at the southern end of the northeast breakwater, where it remains in use today.

In 1862 the training ship *Britannia* – 'the nursery for our future admirals' – was stationed here. She stayed for three years but was transferred to Dartmouth.

As the Royal Navy grew in size towards the end of the nineteenth century additional accommodation was required for training so a succession of training ships moored, each named *Boscawen*.

The completion of the first two arms of the breakwater was marked by an impressive ceremony on 10 August 1872. Both the Channel and Reserve Squadrons, headed by huge broadside ironclads including *Minotaur*, *Agincourt*, *Achilles* and *Hercules*, gave a royal salute to welcome the Prince of Wales for the event, where he laid the last stone. A total of 5,731,376 tons of stone had been hewn by hundreds of convicts. The cost was £1,167,852. These government works and the presence of naval and military personnel had an economic impact on the island and south Dorset that was to last for 150 years.

Two final breakwater arms completed the enclosure of Portland Harbour in 1906 as a counter-measure against torpedo attack. This was a time of rapid transition from coal- and steam-powered vessels to oil.

New onshore facilities saw the expansion of the dockyard to include a range of buildings, such as offices and storehouses. Further afield was a naval hospital, canteen and recreation ground.

When the First World War broke out in 1914 the Grand Fleet assembled in Portland Harbour before sailing to Scapa Flow. The old battleship HMS *Hood* was scuttled to permanently block the vulnerable South Ship Channel between the first two breakwater arms.

Portland's naval base returned to normal peacetime operations after the war. Despite the Royal Navy having used Portland as a base since 1845, it was not until 11 December 1923 that Portland was officially declared as HM Naval Base Portland (HMNB Portland). In 1924, Portland's anti-submarine establishment was commissioned.

The harbour played a vital role in the Second World War. From 1940, the harbour came under fierce German air attack. Over the course of the war Portland suffered forty-eight air attacks, in which 532 bombs were dropped. One bombing was of the anti-aircraft ship *Foylebank* in July 1940. Crewman Jack Mantle was mortally wounded but valiantly stayed at his

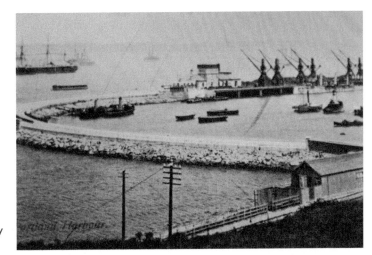

Breakwater in the early twentieth century.

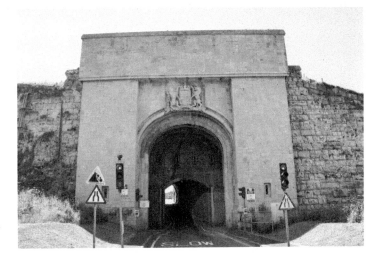

Citadel entrance. Now known as the Verne.

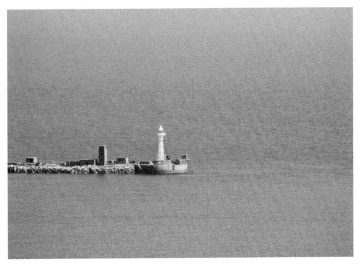

The lighthouse on the end of the breakwater.

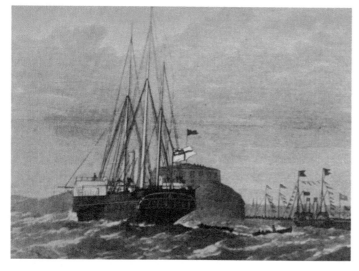

The arrival of the royal yacht in the breakwater on 10 August 1872.

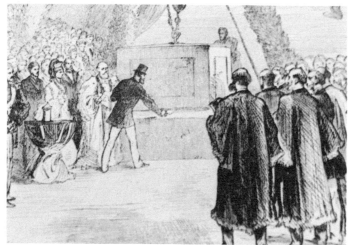

The king lays the last breakwater stone.

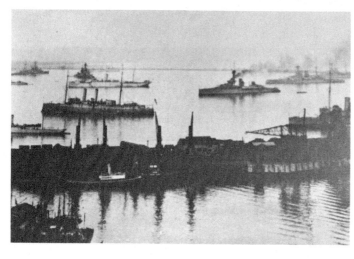

The First World War fleet in Portland Harbour.

post firing at the enemy raiders until he fell. For this he was awarded the Victoria Cross. He is buried in Portland's Royal Naval Cemetery, which overlooks the harbour.

In 1940 the underground Portland Naval Communication Headquarters was constructed, built into the hillside at the rear of the dockyard.

On 1 May 1944 the base was commissioned as USNAAB (United States Navy Advanved Amphibious Base) Portland-Weymouth. Both Portland and Weymouth were major embarkation points for American troops, particularly the US 1st Division, who embarked for Omaha Beach in June 1944. The king, Prime Minister Churchill and Free French leader General De Gaul came to see the great D-Day preparations. The entire harbour was buzzing with activity: 418,585 troops and 144,093 vehicles left this port in a just a few hours. Portland's contribution was noted by messages from the United States: 'For over a year your Island of Portland has been a key factor in the movement of troops and their weapons of war to the far shore in the liberation of the Continent' and 'You are the biggest little port in the world, you have been wonderful.'

The American ambassador commemorated this by unveiling a plaque in Portland's Victoria Gardens in August 1945.

Post-war peace brought many changes. Ships of all NATO countries now frequented the harbour.

In wake of the Cold War, construction of the Admiralty Gunnery Establishment was completed at Barrow Hill near Southwell village in 1952. At East Weares, HM Underwater Detection Establishment was also established. Both became part of the Admiralty Underwater Weapons Establishment in 1959 as AUWE(S) and AUWE(N) respectively.

The AUWE became infamous in 1961 for espionage infiltration, known as the Portland Spy Ring. Two civil servants named Ethel Gee and Harry Houghton, who met while working at the Underwater Weapons Establishment, were passing on secrets to a go-between. Mr Lonsdale,

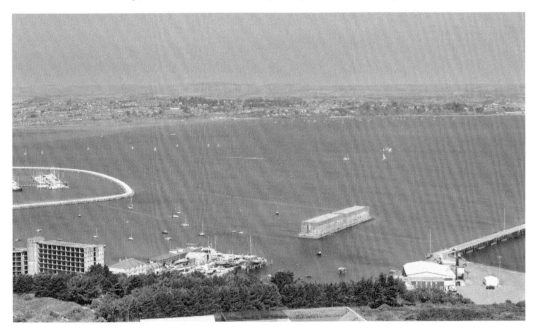

In 1946 ten enormous Mulberry Harbour 'Phoenix Caissons' units were towed here from France (used to create a port for D-Day). The Mulberry Harbour is in the centre of the photo.

would take the information to a Mr Kroger, who then transmitted the secrets to Moscow. Houghton and Gee were each sentenced to fifteen years in prison. They both served ten years, changed their names and got married after their release. In June 1961 an official report blamed lax security at the Admiralty for the Portland spy ring.

In 1959 the Royal Naval Helicopter Station was established. The old mere (where the sheep were once dipped) was filled in to create the naval largest helicopter airfield in Europe. HMS *Osprey*'s helicopter squadrons were prominent in many incidents around the globe, including the Falklands and Gulf conflicts, while its search and rescue service has saved countless lives around Dorset's coast over the years. For the next forty years, RNAS Portland was one of the busiest air stations on the south coast.

The outbreak of the Falklands War in 1982 saw Portland's facilities in constant demand. The first ship to depart the United Kingdom ahead of the British Task Force was RMAS *Typhoon*, which sailed from Portland.

HMNB Portland continued to operate as an important naval base into the late twentieth century. Work commenced in 1984 on a £30 million scheme at Castletown with the construction of two large accommodation blocks and a state-of-the-art sports centre known as the Boscawen Centre. However, the end of the Cold War in 1991 led to a review of the country's existing defence budget.

The government decided in 1993, despite local opposition, that Portland's Royal Naval Base was to close. In addition Portland's two research establishments were to close, although RNAS Portland and the research site at Bincleaves would remain operational.

HMNB Portland ceased operations on 21 July 1995, with the flag officer Rear Admiral John Tolhurst departing on HMS *Argyll*, moving his command to Plymouth. It was a low-key affair, ending a long and proud era for the Island.

The Royal Navy Westland Lynx on display at Portland Marina.

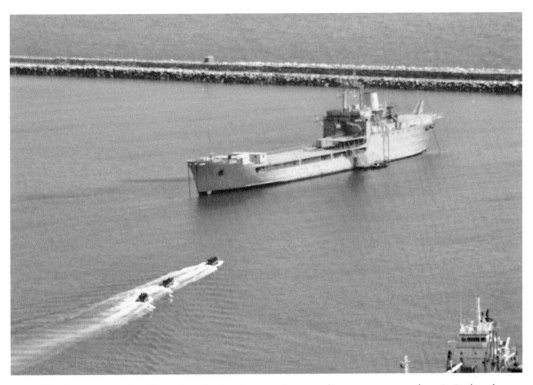

The breakwater is still used today by the navy, but nowhere near as much as in its heyday.

An arm of the breakwater.

The breakwater, taken at the Jailhouse Café, which sadly closed in July 2018.

A local landmark left over from the navy.

The naval base closed on 29 March 1996 when the harbour was acquired by Portland Port Ltd. RNAS Portland closed in 1999.

The combined closure of all naval-related establishments at Portland was believed to have cost the area 4,500 jobs, along with a loss of £40 million to the local economy. Until this point 41 per cent of the local workforce had defence-related jobs.

Portland Port Ltd purchased the harbour on 12 December 1996. Their aim was of developing the ship repair, leisure and tourism potential of the harbour. Portland Port Group became Statutory Harbour Authority for Portland Harbour on 1 January 1998, replacing the Queen's Harbour Master. In 2004, changes led to Portland Harbour Authority Ltd becoming the Statutory and Competent Harbour Authority, and Portland Port Ltd the Port Operator.

One of the first arrivals at the port was the prison ship HM *Prison Weare*. The ship was bought by the prison service from the US in 1997 to ease overcrowding in British jails. A total of 250 jobs were instantly created in the Portland area, which had suffered unemployment after the navy left. It boosted the economy by £9 million a year. But it was controversial. It held up to 400 male inmates and attracted unfavourable comparisons with Victorian prison hulks. But it did become something of a tourist attraction. It closed in 2006.

The Portland Harbour Revision Order 2010 provided for the creation of new berths and hardstand areas at the port in order to allow increased commercial activities over the next fifty years. One of these activities is cruise ship calls bringing visitors to the Dorset area. The Britannia Cruise Terminal opened in July 1999 and was refurbished in 2005. In recent years the number of cruise ship calls have increased at the port. In 2009 there were four ships and 2,000 passengers. In 2018 the port handled thirty-two cruise ships, bringing nearly 39,000 passengers into Portland. This is a trend that Portland Port is keen to continue.

After significant marine civil engineering works involving reclaiming part of the harbour, building new slipways, pontoons, berths and work to the breakwater, the Weymouth and Portland National Sailing Academy (WPNSA) opened in 2005 on the former RNAS site. These developments led to an economic uplift and a chance to host part of London 2012 Olympic and Paralympic Games.

It hoped to bring 30,000 visitors every day, bringing millions into the local economy, and show the world what Dorset and the Jurassic Coast has to offer. It was hoped that it would leave a long-lasting legacy with new business opportunities, improved infrastructure and a sense of optimism and confidence.

Olympic-related schemes helped pump £177 million of funding into the Weymouth and Portland area for facilities, regeneration and transport projects. This included the £87 million relief road and transport scheme. A transport package, including controversial intelligent traffic-light system, cost £15. 5 million, including a £4 million investment in new bus services with bus stops and real time bus and car park information. There was a £300,000 investment by Dorset County Council in a Dorset Traffic Control Centre and more than £50,000 worth of railway station improvements in Weymouth. Other projects included almost a £40 million investment in improving broadband across Dorset. But the hoped-for legacy has proved controversial.

A report from the House of Lords Olympic Legacy Committee have claimed promotion after the 2012 Games were too 'London-centric'. It said footage of the Dorset venue could have been used to boost tourism, while requests for public money for major events had been turned down. It said 'fantastic' television coverage from the Games showing the area, the Georgian seafront and the Jurassic Coast World Heritage Site had not been used.

The Olympic rings.

Portland Marina.

Portland Marina walkway.

'The area has potential for tourism expansion and water sports and outdoor activity,' the report stated. 'But despite requests to Visit England and Visit Britain this has not been achieved, which is a huge missed opportunity.' The report also said it was unclear who was responsible for taking the legacy forward outside London, leading to the perception the process was too 'London-centric'. Despite this report it was a fantastic experience for locals.

HM PRISON PORTLAND

Portland's convict establishment originated with the building of the Breakwater. A temporary convict establishment was announced for Portland in 1846. The main reason was to address the concerns of colonists over the number of convicts being transported. The convicts incarcerated there would primarily provide labour within the Admiralty quarries to provide stone for the Breakwater. Originally able to accommodate 840 convicts, it was established on the east side of the island on a bleak clifftop on former common land, which had to be purchased by the government. Construction began in January 1848 and 1,300 men were hired to build the prison, resulting in a huge influx of labourers into Portland.

The new establishment was declared ready for use in November 1848, with the first group of convicts – amounting to sixty-four men – arriving at Castletown aboard the HM steamer *Driver* on 24 November and marching up to the prison.

The prison's initial accommodation was made up of two detached cell blocks built of timber and stone. Each block had four large open halls, with four tiers of cells on each side. Cells were small at 7 feet in length, 4 feet wide, 7 feet high and separated from one another with corrugated-iron partitions. They had simple furnishings including a hammock, stool, table and shelves.

After a period of solitary confinement, the convicts were then to undertake hard labour in the quarries. In return for good behaviour convicts would be given a 'Ticket of Leave', which would grant them certain freedoms when they were sent to the Australian colonies.

The conditions were harsh. Convicts were woken at 5.30 a.m. by the prison bell. Cells were checked and prison orderlies collected the slops. Breakfast was in their cells at 6 a.m. and consisted of 10 ounces of bread and a pint of tea. It was followed by morning prayer at 7 a.m. Convicts then stood in rows and were searched, frisked for tobacco and weapons. This search was repeated three times a day and could result in a full strip.

One punishment was for a prisoner to be tied to steel triangle and have three-dozen lashes. A young convict died from flogging for burning some paper and clothes in his cell in 1869. The number of deaths were reaching one a week. The inhumane treatment was raised in Parliament at least three times between 1875 and 1890. Many attempted – but unsuccessful – escapes were made. Assaults on warders were seen on occasion and three were murdered between 1862 and 1870, with all three convicts being executed as a result. There were 200 warders, one to eight prisoners, in addition to 400 soldiers in the barracks. In 1869, despite local petitions, the government announced that the prison would become a permanent establishment.

Grove village developed as a result of the establishment, with many properties being erected along Grove Road to house prison warders and staff, including the governor, deputy governor, chaplain and surgeon. Apart from the main stretch of properties along Grove Road, quarters were established within and around the prison's boundaries. It was a close-knit community. There was a school built in 1872 for their children. There were clubs such as the Borstal Officers Recreational – originally comprising of three army huts with multiple rooms (concert, reading, billard, games and a canteen). There was a prison officers' football team. Their wives also had their own entertainment, such as the Womens' Institute, known locally as the Borstal Wives, and organised different social activities including the annual pancake race.

As work in the quarries progressed, expansion allowed 1,520 convicts to be incarcerated at Portland by 1853.

Prisoners worked ten hours day and became a tourist attraction, with visitors arriving on a Cosens steamer to watch the convicts at work. Along Grove Road a number of residents opened tearooms and cafés in the upstairs of their houses.

After the completion of the harbour's original two breakwater arms in 1872, the Admiralty quarries continued use on a smaller scale as part of the convicts' daily labour routine.

Portlanders hoping that the ending of transportation in 1868 would bring the closure of the prison, but the prison department announced in 1869 that the prison would be made permanent.

In March 1921, the government announced that Portland's convict establishment would be converted into a borstal institution. At the time, juvenile crimes were on the increase and the existing four borstals were at maximum capacity.

The normal routine at the borstal was an early morning exercise, followed by eight hours' work in the shops, the prison farm or at various institutional jobs. School, gym classes or recreation time took place during the evening until 9.30 p.m. The institution used a house system to develop team spirit and healthy competition. New arrivals at the borstal were

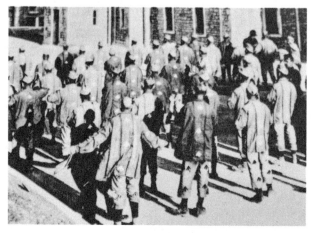

Prisoners being searched.

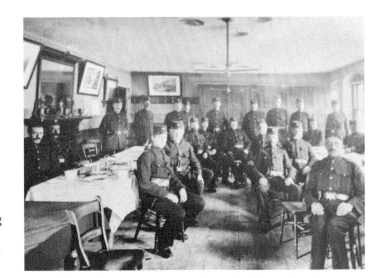

Prison officers relaxing in their social club, taken around the early twentieth century.

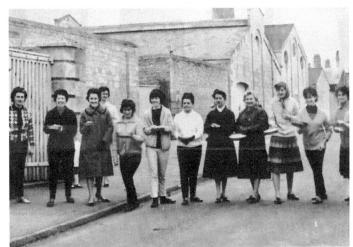

The first pancake race was organised by the Portland Women's Institute and took place in 1964.

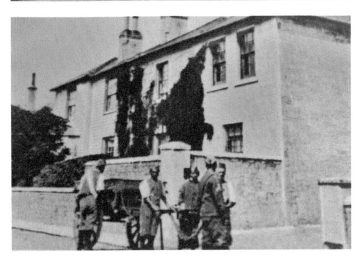

Convicts on work duty.

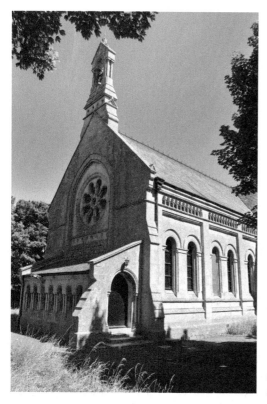

Left: Between 1870 and 1872 convicts constructed St Peter's Church, just outside the prison.

Below: Grove Museum and garden. It is located within the former deputy governor's house, across from the original gatehouse of the prison. It opened in 2014.

dressed in brown, but after eight to ten months of good conduct they had the ability to earn the right to wear blue clothing and receive additional privileges. With an increased focus on sports, an abandoned pit within the former quarries was transformed by borstal boys into a stadium between 1931 and 1936. Once completed, sports days and other events were held there over the following decades.

On 15 August 1940, a raid saw the borstal's infirmary receive a direct hit, killing four boys and leaving others severely injured.

In November 1965, prison officer Derek Lambert was murdered by Borstal boy Roger Keith Maxwell.

The UK borstal system was abolished by the Criminal Justice Act 1982, resulting in Portland's establishment becoming a youth custody centre in 1983. The centre was rerolled as a young offenders institution in 1988, holding up to 519 young males aged eighteen to twenty-one. A wide range of vocational training was made available to the young offenders, including courses in construction and mechanics.

The prison's role changed again in April 2011 when it became an adult/young offenders establishment. In late 2013, it was announced that the prison would also serve as a resettlement prison, succeeding the then-closed HM Prison Dorchester in the role. As of 2018, the prison holds 530 inmates.

THE VERNE

Originally built by convicts as the Verne Citadel, it is on a 500-foot-high summit. Made from 3 million convict-made bricks. It received its first regiment in 1873. The citadel's defensive role had largely come to an end in the 1900s, and by 1903 its primary role was as an infantry barracks. From 1937, the citadel was used as an infantry training centre and after the Second World War the final military use was by men of the Royal Engineers.

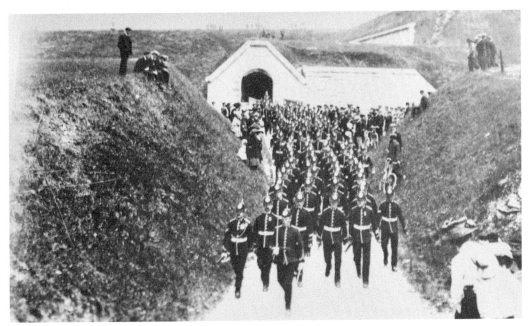

Leaving the Citadel in 1928 – possibly St George's Day.

It lay vacant after the war. Following the Criminal Justice Act of 1948, the government approved plans to transform the southern region of the citadel into a prison despite strong local protest.

The first prisoners, an advance party of twenty, arrived on 1 February 1949, while the first governor to be appointed at the new facility was Mr John Richards. It soon reached its capacity of 300. Not much time had passed when the Verne saw its first escapee: David Connor, who was found missing on 22 April, but was recaptured later that day near Wareham. A further twenty-two escapes were seen up to the end of 1954 alone, and further escapes continued throughout the prison's life.

In December 1955, Verne inmate John Hannan escaped just a month into his sentence with a fellow prisoner – Gwynant Thomas – using knotted sheets to scale the prison wall. Hannan had been sentenced to twenty-one months for car theft and the assault of two police officers. The pair made their way along the railway line from Portland to the mainland and broke into a local petrol station and stole beer, cigarettes and overcoats. Although Hannan's companion was recaptured the following day, Hannan himself evaded capture. In 2001, he entered world record books as having been on the run longer than any other prisoner in the world. He holds the world record for the longest escape from custody after fleeing the Verne at Portland in 1955, pipping infamous escapees such as Ronnie Biggs to the title. An appeal in the force newspaper *Blueprint* asked: 'Have you seen John Patrick Hannan? He is described as five feet seven inches with brown hair, blue eyes and proportionate build.'

The plea also addressed the man himself: 'If you read this Mr Hannan please write in, we'd love to hear from you.'

By 1977, around 500 prisoners were serving their sentences there, and from the 1980s the Verne was considered a C-category prison. The prison population was 521 in 1988 and 552 in 1996. All prisoners were serving medium to life sentences.

It was closed in November 2013, with all prisoners being transferred to other suitable prisons. Conversion work commenced with it to become an immigration removal centre.

The first detainees arrived on 24 March 2014. In 2017, it was announced that the centre would close on 31 December 2017 and revert to a prison in 2018. The prison service remains one of Portland's main employers.

THE FUTURE FOR WEYMOUTH AND PORTLAND

Weymouth and Portland is still a popular tourist destination, and tourism in Weymouth is still its largest industry. But behind the façade of the seaside holiday town lies a community in need of a boost.

Both Weymouth and Portland have suffered through lack of central funding. To improve local job opportunities there is a need to invest in the essential foundations of a successful economy: road, rail and skills. Following the closure of Portland naval base there have been opportunities seized for regeneration and new industrial and commercial development at Osprey Quay, Southwell business park and Portland Port. But there are still a lot of improvements to be done if Weymouth and Portland are to become more prosperous.

There is a huge opportunity for the development of ecotourism in Weymouth and Portland. Perhaps again this can become a place that people visit for health and wellbeing. A place to cycle, enjoy nature and the outdoors. Weymouth and Portland badly miss high-tech jobs. Perhaps we may see a growth in green technologies such as tidal and off-shore wind energy.

BIBLIOGRAPHY

Bettey, J. M., *The Island and Royal Manor of Portland* (1970).

Boddy, M. and J. West, *An Illustrated History* (1983).

Boddy, M. and J. West, *Weymouth An Illustrated History* (1983).

Chedzoy, A., *Seaside Sovereign: King George III at Weymouth* (2003).

Clammer, R., *Cosens of Weymouth 1848–1918* (2005).

Hackman, Gill, *Stone to Build London* (2014).

Norris, Stuart, *An Illustrated History* (2016).

Toms, Cyril, *The Seiners and The Knocker Up* (1994).

Winter Saunders, K., *A Child of Chiswell Remembers* (1987).

ACKNOWLEDGEMENTS

I have always had an interest in local history and the last few months have been a great joy delving into the past of the wonderful areas of Weymouth and Portland. I have had a lot of help and advice along the way and I would like to thank the following people: firstly, to all the staff and volunteers at Portland Museum who have allowed me to peruse their collections and use some of their images. Also, to the staff and volunteers at Weymouth Museum who allowed me access to their fabulous photographic collections and exhibits. Finally, I would like to thank my family: Russ for his enthusiasm and patience, Astrid for her technical support and Jarvis for his encyclopedic memory.